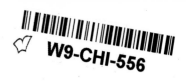
THE ROMANTIC VISION OF
CASPAR DAVID FRIEDRICH

THE ROMANTIC VISION OF CASPAR DAVID FRIEDRICH

Paintings and Drawings from the U.S.S.R.

ESSAYS BY

ROBERT ROSENBLUM AND BORIS I. ASVARISHCH

EDITED BY

SABINE REWALD

THE METROPOLITAN MUSEUM OF ART, NEW YORK

THE ART INSTITUTE OF CHICAGO

Distributed by Harry N. Abrams, Inc., New York

The exhibition is made possible by the Government of The Federal Republic of Germany.

This publication was issued in connection with the exhibition
*The Romantic Vision of Caspar David Friedrich: Paintings and
Drawings from the U.S.S.R.*, held at The Art Institute of
Chicago from November 1, 1990, to January 6, 1991, and at
The Metropolitan Museum of Art from January 23, 1991,
to March 31, 1991.

Copyright © 1990 The Metropolitan Museum of Art

Published by The Metropolitan Museum of Art, New York

John P. O'Neill, Editor in Chief
Joanna Ekman, Editor
Bruce Campbell, Designer
Heidi Colsman-Freyberger, Bibliographer
Peter Antony, Production

Translation of the Russian text by Wendy R. Salmond

Type set by U.S. Lithograph, typographers, New York
Printed and bound by Colorcraft Lithographers, Inc., New York

Frontispiece: Georg Friedrich Kersting, *Caspar David Friedrich in His Studio*, ca. 1812.
Oil on canvas, 20⅛ × 15¾ in. (51 × 40 cm). Nationalgalerie, Staatliche Museen
 Preussischer Kulturbesitz, Berlin
Jacket: Detail of *On the Sailboat* (page 48)

The color photographs were supplied by the State Hermitage Museum, Leningrad, and the Pushkin
State Museum of Fine Arts, Moscow. Unless otherwise indicated, the black-and-white photographs
were supplied by the institutions named in the captions. Figs. 36 and 39 by Klaus G. Beyer AFIAP,
Weimar. Fig. 40 from Karl-Ludwig Hoch, *Caspar David Friedrich in Böhmen* (Dresden: Verlag der
Kunst, 1987). Courtesy of the publisher.

LIBRARY OF CONGRESS CATALOGING-IN-PUBLICATION DATA

Friedrich, Caspar David, 1774-1840.
 The romantic vision of Caspar David Friedrich : paintings and drawings
 from the U.S.S.R. / essays by Robert Rosenblum and Boris I. Asvarishch ;
 edited by Sabine Rewald.
 p. cm.
 Catalog of an exhibition containing works from the Hermitage Museum,
Leningrad, and the Pushkin Museum, Moscow.
 Includes bibliographical references.
 ISBN 0-87099-603-7 — ISBN 0-8109-6402-3 (Abrams)
 1. Friedrich, Caspar David, 1774-1840—Exhibitions.
 2. Gosudarstvennyĭ Ermitazh (Soviet Union)—Exhibitions.
 3. Gosudarstvennyĭ muzeĭ A.S. Pushkina—Exhibitions.
 I. Rosenblum, Robert. II. Asvarishch, Boris. III. Rewald, Sabine.
 IV. Gosudarstvennyî Ermitazh (Soviet Union) V. Gosudarstvennyĭ muzeĭ
 A.S. Pushkina. VI. Title.
 N6888.F7626A4 1990
 759.3—dc20

 90-13402
 CIP

By giving the commonplace higher meaning—the familiar an enigmatic look, the known the prestige of the unknown, the finite the appearance of the infinite—I make it *Romantic*. . . .

Novalis, "Logologische Fragmente II," in *Das Philosophische Werk I* (1798)

Contents

Acknowledgments

Many participated in this project. At The Metropolitan Museum of Art, grateful acknowledgment is due to Gary Tinterow, Engelhard Associate Curator of Nineteenth-Century European Paintings; and Anne M. P. Norton, Research Associate, Department of European Paintings. Mahrukh Tarapor, Assistant Director, is to be thanked for her assistance. Much help on the catalogue was given at the Metropolitan Museum by John P. O'Neill, Barbara Burn, Teresa Egan, Peter Antony, Barbara Cavaliere, and Steffie Kaplan, all of the Editorial Department, and by William S. Lieberman, Chairman, Department of 20th Century Art; and by Joanna Ekman, Bruce Campbell, Heidi Colsman-Freyberger, Josephine Freeman, Walter J. F. Yee, and Ulrike McGinty. Helmut Börsch-Supan, Peter Dreyer, Ulrike Gauss, Albert Kostenevich, John Leighton, Peter Nathan, and Peter-Klaus Schuster provided information and assistance. At The Art Institute of Chicago, thanks are due to Douglas Druick, Searle Curator of European Painting; Martha Wolff, Curator of European Painting Before 1750; Gloria Groom, Assistant Curator of European Painting; Dorothy Schroeder, Assistant to the Director; and Mary Solt, Executive Director of Registration. The Art Institute's showing of the exhibition has been made possible through the generous support of their Auxiliary Board, chaired initially by Andrew M. Rosenfield and then by Mary Carol Fee.

S R

Foreword

The Romantic Vision of Caspar David Friedrich: Paintings and Drawings from the U.S.S.R. is the first exhibition in the United States to be devoted to the works of this German Romantic painter, who was a master at transforming his native landscape into hauntingly evocative images—the Baltic Sea at twilight, the rugged Riesengebirge at dawn, the spires of Gothic churches soaring next to a forest of masts in a harbor at midnight.

This exhibition continues the fruitful cultural exchange between the United States and the U.S.S.R. that brought to these shores a rich selection of Dutch and Flemish paintings from the State Hermitage Museum in Leningrad in 1988 and *From Poussin to Matisse: The Russian Taste for French Painting* in 1990. The Art Institute of Chicago and the Metropolitan Museum reciprocated with an important exhibition of French nineteenth-century and early twentieth-century paintings in 1988 and a selection of medieval art from late antiquity to the High Gothic period in 1990—shows that were viewed by large audiences at the Hermitage Museum in Leningrad and the Pushkin State Museum of Fine Arts in Moscow. When the Hermitage celebrated its 225th Anniversary in a large jubilee exhibition from late 1989 to early 1990, both American museums participated with loans from their French, Italian, and Spanish holdings.

It is impossible to study works by Caspar David Friedrich in the United States. There is only one painting by the artist in this country, at the Kimbell Art Museum in Fort Worth. In fact, the paintings and drawings by Friedrich in Russia form the only major collection of Friedrich's works outside of Germany. With the exception of one painting, *In Memory of the Riesengebirge* (1835), these works were all acquired during Friedrich's lifetime for the Russian imperial family, in whose Saint Petersburg or country residences they remained until acquired by the Hermitage and Pushkin museums after 1917. The first imperial acquisition was made as early as 1820, when Grand Duke Nikolai Pavlovich, the future Czar Nicholas I, visited Friedrich's studio in Dresden. The artist's contact with the imperial family continued until his death in 1840 through the intermediacy of the poet and statesman Vasily Andreyevich Zhukovsky, who bought works by Friedrich for the czar and for himself. Boris I. Asvarishch, Curator of European Paintings at the Hermitage, tells the story in his fascinating essay for this catalogue. We also wish to thank Robert Rosenblum, Henry Ittleson, Jr., Professor of Modern European Art at New York University, for his illuminating introductory essay. Sabine Rewald, Associate Curator in the Department of 20th Century Art, graciously brought her considerable expertise in German Romanticism to this project.

ix

We are most grateful to Dr. Boris Piotrovsky, Director of the State Hermitage Museum in Leningrad, for the generous loan of nine paintings and six drawings, and to Madame Irina Antonova, Director of the Pushkin State Museum of Fine Arts, Moscow, for augmenting this loan with another five drawings from her institution's great collection. Albert Kostenevich, Chief Curator of Modern European Painting at the Hermitage, also deserves special thanks for his efforts and advice during the exhibition's preparation. It is entirely fitting that this current celebration of the new openness between our two countries should have as its occasion the transcendent visions of Germany's greatest Romantic painter.

PHILIPPE DE MONTEBELLO
Director, The Metropolitan Museum of Art, New York

JAMES N. WOOD
Director, The Art Institute of Chicago

THE ROMANTIC VISION OF
CASPAR DAVID FRIEDRICH

Fig. 1 Christian Friedrich, after a drawing by Caspar David
Friedrich, *Self-Portrait, Caspar David Friedrich*, ca. 1802. Wood-
cut, 5¼ x 3½ in. (13.4 x 8.9 cm). The Metropolitan Museum of
Art, New York, Harris Brisbane Dick Fund, 1927 (27.11.1).

Friedrichs from Russia: An Introduction

ROBERT ROSENBLUM

 Only a few decades ago, Caspar David Friedrich (1774–1840) had the status of an underground cult figure in America. Known mainly through reproductions, his works were often the objects of a secret passion shared by the most enlightened initiates of the art world. It seems appropriate that the genius of Friedrich, an artist concerned more with feeling and spirit than with palpable objects and paint surfaces, first made itself felt here through the ghostly medium of slide transparencies and illustrations in books; and it is surely a tribute to the potency of his art that, even through black-and-white photographs, his magic could be wrought. To experience his work firsthand, however, one had to travel primarily within German borders, where, in museums from Hamburg and Berlin to Munich and Cologne, a canvas by Friedrich would outshine, like the Holy Grail, all other German Romantic paintings. To be sure, the serious pilgrim might scout out a few works scattered in public collections elsewhere—in Prague, Oslo, Vienna, Winterthur—but short of traveling in Germany, it was long possible, especially in French and Anglo-American museum territory, to ignore this master's existence as totally as it was ignored in many histories of modern painting written before the 1960s.

This situation has changed dramatically in the last two decades. In an almost stealthy way, the full force and historical amplitude of Friedrich's innovative genius have finally earned him international acceptance in the loftiest pantheon of great Romantic artists, in the company of Goya and Blake, Turner and Constable, Géricault and Delacroix. At long last, such major museums as the Louvre, the National Gallery in London, and the Kimbell Art Museum in Fort Worth have managed to acquire small but precious examples of Friedrich's work—paintings that, despite their modest dimensions, instantly radiate the unique intensity of their master's new way of experiencing and expressing the impalpable mysteries of landscape (see Figs. 4–6). But throughout these years of reassessment in the West, there has always been an almost secret anthology of his work in the public collections of a great but remote Eastern nation: Russia.

Russia, in fact, was the first foreign country to acquire Friedrich's work during his lifetime. The two main sources of this patronage could not have been loftier: the throne and the world of literature.[1] The most highborn pa-

3

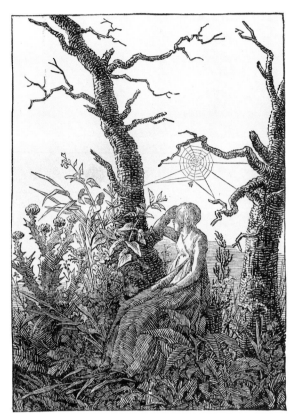

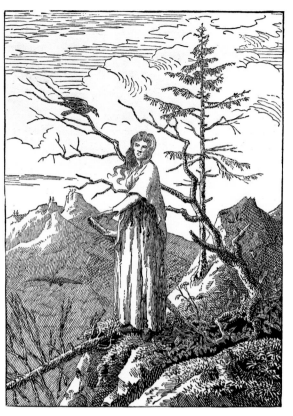

Fig. 2 Christian Friedrich, after a drawing by Caspar David Friedrich, *Woman with a Spider's Web Between Dead Trees*, ca. 1803. Woodcut, 6¹¹/₁₆ x 4¹¹/₁₆ in. (17 x 11.9 cm). The Metropolitan Museum of Art, New York, Harris Brisbane Dick Fund, 1927 (27.11.2).

Fig. 3 Christian Friedrich, after a drawing by Caspar David Friedrich, *Woman with a Raven near an Abyss*, ca. 1803. Woodcut, 6⅝ x 4¹¹/₁₆ in. (16.9 x 11.9 cm). The Metropolitan Museum of Art, New York, Harris Brisbane Dick Fund, 1921 (21.11.3).

tron was Grand Duke Nikolai Pavlovich (1796–1855; the future Czar Nicholas I, r. 1825–55), whose marriage in 1817 to Princess Charlotte Louise (later Alexandra Fedorovna), the daughter of the Prussian king Frederick William III, secured an ongoing political and cultural connection between Germany and Russia. The most learned was the writer Vasily Andreyevich Zhukovsky (1783–1852), a member of Friedrich's own generation, who fanned the new fires of Romanticism with his nationalist poetry and translations of such German and English Romantics as Goethe and Schiller, Byron and Southey. Both the czar-to-be and the poet had, in fact, paid visits to Friedrich's Dresden studio (in 1820 and 1821, respectively), beginning a dialogue between the German painter and Russian art lovers that would be sustained throughout the remaining twenty years of the master's life. Zhukovsky, in particular, formed a sizable collection of Friedrich's paintings and drawings in his home, creating a magical environment where visitors would marvel at unfamiliar images of haunting melancholy and might even be prompted, as was the historian

and statesman Alexander Turgenev in 1825, to visit the artist in Dresden. Zhukovsky's passion for Friedrich's art was later transformed into personal compassion; for after a stroke in 1835 left Friedrich paralyzed and unable to work, Zhukovsky arranged in 1838 to have money sent from Saint Petersburg to the artist's desperately needy family.[2] Most poignantly, the Russian poet visited Friedrich in Dresden only weeks before the master died on May 7, 1840, and commented succinctly in his diary: "At Friedrich's. A sorrowful ruin. He wept like a child."[3]

After the artist's death and with the mid-century cooling of Romantic emotions, the fervor of his Russian patronage disappeared, and so, too, did many of his works. Perhaps some of these will be rediscovered one day in a new wave of art-historical research into the dispersal of nineteenth-century imperial and private collections in Russia. For the time being, however, the Hermitage can boast nine paintings and six drawings by Friedrich, enough to match the holdings of almost any German museum; and in Moscow, the Pushkin Museum can further amplify this Russian inventory with one painting and nine drawings. On a few earlier occasions, some of these works crossed Russian borders, especially during the bicentenary year of Friedrich's birth,

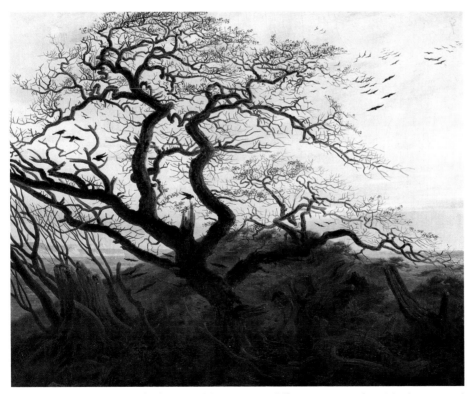

Fig. 4 Caspar David Friedrich, *Raven Tree*, ca. 1822. Oil on canvas, 21¼ x 28 in. (54 x 71 cm). Musée du Louvre, Paris, R.F.1975–20 (Photograph courtesy Galerie Nathan, Zurich).

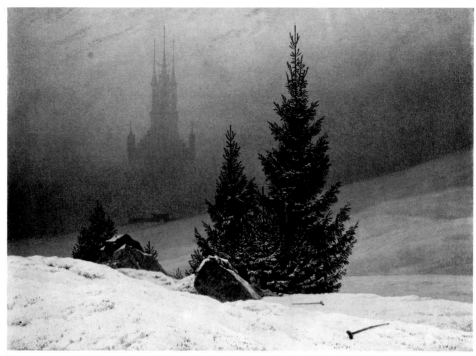

Fig. 5 Caspar David Friedrich, *Winter Landscape*, 1811. Oil on canvas, 12¾ x 17¾ in. (32.5 x 45 cm). National Gallery, London.

1974. At that time, a particularly generous loan was made to West Germany for a major Friedrich retrospective in Hamburg,[4] and in the same year, the German Democratic Republic organized for Dresden an exhibition of Friedrich and his circle,[5] which also included many works from Russia and which was eventually sent, in 1978, to Tokyo and Kyoto.[6] In 1976, a smaller group of Friedrich's works from Russia was included in a survey of German Romantic painting held in Paris.[7] But with these important exceptions, most of the Russian Friedrichs have stayed at home in the country where they were first cherished.

The chance, then, to see in Chicago and New York a group of nine paintings and eleven drawings from the Hermitage and the Pushkin Museum is, in many ways, a landmark event. Apart from being a happy symptom of the crumbling of political boundaries in the 1990s, it will also offer to many a first occasion to see what is virtually a mini-retrospective of this master. (The only other time Friedrich could be seen in any quantity at the Metropolitan Museum was in 1981, when seven of his paintings, plus one dubious attribution, were included in the exhibition *German Masters of the Nineteenth Century*.) Visitors will be struck at once by one of the abiding marvels of Friedrich's genius: his ability to depict an awesomely still, silent, and unbounded void

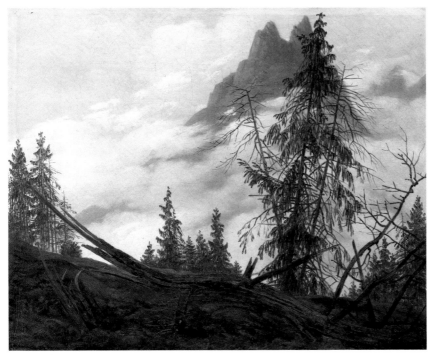

Fig. 6 Caspar David Friedrich, *Mountain Peak with Drifting Clouds*, ca. 1835.
Oil on canvas, 9⅞ x 12¹/₁₆ in. (25.1 x 30.6 cm). Kimbell Art Museum, Fort Worth.

that seems to radiate from the vantage point of a lone viewer into territories of space and emotion no longer chartable by rational means. For Friedrich, all earthly paths, whether humble or exalted, lead to the unknown. If we silently take our place next to a young couple in the bow of a sailboat, we find ourselves contemplating with them not the pleasures of an idle weekend but a sunshot mirage of a distant city as otherworldly as the Heavenly City of Jerusalem. If we find ourselves on the brink of the sea, we are not simply taking a walk on the shore but are obliged to stand in solemn silence, communing with the awesome rising of the moon in the vastest of skies. If, on a country walk, we stumble onto the ruins of a Gothic monastery (Fig. 7), we must suddenly position ourselves on a central axis of perfect symmetry created by an arched stone skeleton, peering, together with another motionless visitor, into a barely visible landscape glowing with a rainbowlike sunset. And even if we find ourselves in an ordinary domestic interior in front of a spotless window that frames a pair of potted plants bathed in sunlight (Fig. 8), we are no less prompted to project our feelings into a distant and mysterious luminosity that we intuit beyond closed windows and material walls. These voyages into a dilating immensity of space can be quite literal: at times, Friedrich will locate us at the loftiest heights of a mountain range, finally

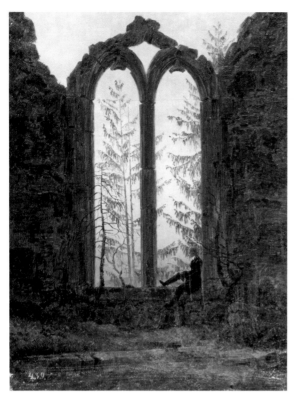 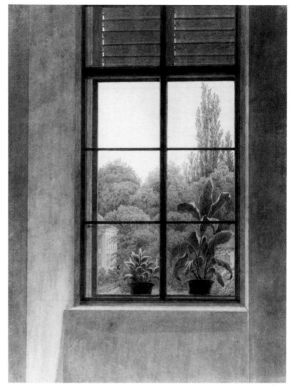

Fig. 7 Caspar David Friedrich, *The Dreamer*, ca. 1835 (p. 78).

Fig. 8 Caspar David Friedrich, *Window with a View of a Park*, ca. 1806–11 or 1835–37 (p. 42).

setting our feet down at the very last limits of terrestrial grass and soil, and compelling us to glimpse from there the numbing panorama of a no-man's-land whose even higher, snowbound peaks can no longer be approached by foot but only by the farthest reaches of imagination. Such longings to envision another realm, freed from the puny laws of gravity and from earthbound matter, symbolically take flight in a remarkable drawing of an owl high in a night sky, its head and outspread wings almost fused with the perfect circle of a full moon (Fig. 9). This eerie vision of nocturnal infinitude is freed from all tethers of ground and horizon, wafting us now into a dark and alien void, far beyond the capacities of human navigation.

How does Friedrich persuade us, again and again, that we are at the very edge of the natural world, ready at last to immerse ourselves in something that, for want of a better word, must be called the supernatural—a domain of mystical speculations about human life and afterlife that before the Romantics found a proper home inside the church? Looked at only from the vantage point of subject, his work barely breaks new ground, for it falls mainly into the most familiar secular types that first flourished in seventeenth-century Holland—marine, landscape, genre, church views—and that had endless prog-

eny in Northern Europe. Indeed, even Friedrich's mysterious pair of swans might be accommodated into the traditional pigeonhole of animal paintings that proliferated in Dutch art. This said, we nevertheless immediately know that Friedrich's vision of such commonplace motifs is different, marking a quantum leap into unexplored regions.

The ordinary perceptions of space and time, which we might unthinkingly apply to Friedrich's themes, no longer obtain. In place of the animated, oblique views of his Baroque ancestors—views that suggested a casual, everyday contact with a familiar world of sky and buildings, earth and sea, mountains and plains—Friedrich offers a rigidly frontal view that would arrest all motion and align the spectator on a central axis, as if before an altarpiece. Throughout his work, a lucid geometric order, both explicit and implicit, reigns. A mountain vista with two foreground peaks seems to be bisected exactly by an invisible but abiding vertical presence (Fig. 10); an owl in flight is captured forever in the circular center of a drawing; a moon and its watery reflection create a subliminal axis that crosses the precise center of a view of fishermen's nets left to dry on the shore; the symmetry of a Gothic window, found in a forest ruin, locks us into place before an imaginary shrine. Even when figures, their backs to us, contemplate moonrises (Fig. 11), sunsets, and ghostly ships from off-center positions, we nevertheless intuit a secret axis of purest symmetry toward which they, and everything around them, will eventually gravitate and come to rest. The rational world of compass and ruler (whose marks are occasionally discernible on Friedrich's drawings) is transformed into mystical, eternal structures, like holy emblems of a new but unnameable faith that can turn secular experience into something sacred. Similarly, the continuous ticking of measurable time that clocks our ordinary lives seems to have stopped as Friedrich transports us to an otherworldly experience of rapt meditation in which the next movement—the setting of the sun, the rising of the moon, the passing of a cloud—may take us beyond the threshold of the natural world.

Characteristically, Friedrich's spaces offer new and emotionally evocative contrasts between a shallow, immediate foreground and an otherworldly, unattainable distance beyond. Whether we are standing in front of a Gothic arch or a domestic window, whether our feet

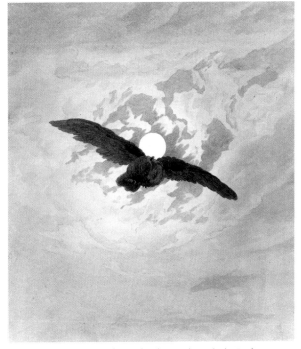

Fig. 9 Caspar David Friedrich, *Owl in Flight Before a Full Moon*, 1836–37 (p. 86).

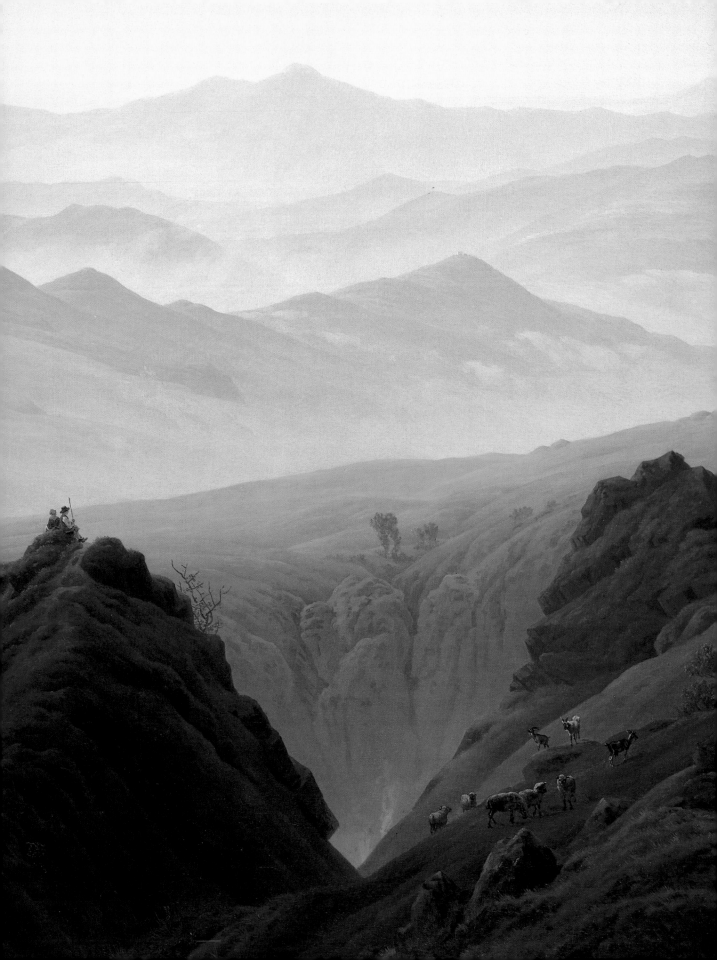

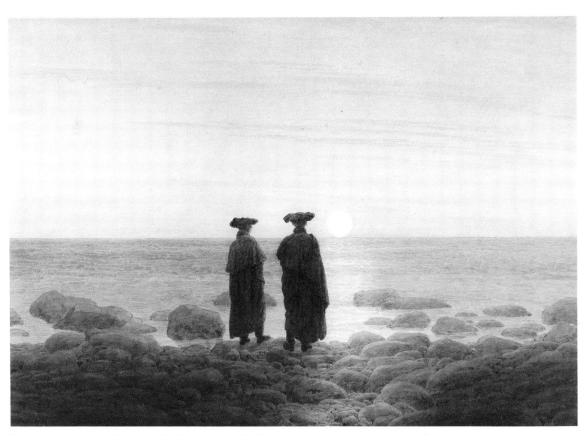

Fig. 11 Caspar David Friedrich, *Two Men by the Sea at Moonrise*, ca. 1835–37 (p. 90).

are on the edge of the sea or at the brink of an abyss, we have always reached the limits of the material world, where we must halt our physical movement and confront some ultimate vision, more spirit than substance. The middle ground, which in seventeenth- and eighteenth-century paintings might be traversed by land or by sea to reach the horizon, has vanished, leaving both Friedrich's silent *dramatis personae* and us, the spectators, before what seems the last scrim of earthly experience. Beyond this foreground, strange presences lie, whether they are perceived only in tiny fragments, as in a diminutive but uncannily luminous park view on the other side of a window, or in breathtaking panoramas that, as in the expansive vista of the Riesengebirge, may make us feel that we have been elevated to an exalted destiny that can no longer be entered by physical means. The prevalence in Friedrich's works of figures who stand mesmerized, singly or in pairs, before these mirages, their backs to the spectator, reinforces this experience of having arrived at the last outpost of the terrestrial world, beyond which there are only spiritual means of transportation.

At times, Friedrich's imagination was nourished by documentary im-

Fig. 10 Detail from Caspar David Friedrich,
Morning in the Mountains, 1822–23 (p. 60).

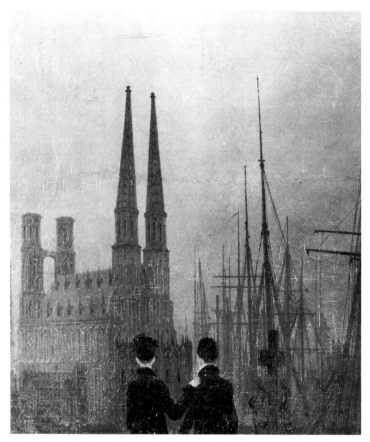

Fig. 12 Detail from Caspar David Friedrich, *Sisters on the Harbor-View Terrace (Harbor by Night)*, ca. 1820 (p. 52).

ages of places he had never seen—the Alps, the Arctic, the Temple of Juno Lacinia at Agrigento—but generally, he chose his motifs from things he had scrupulously observed firsthand: the maritime activities of sailors and fishermen in his native Greifswald; the overcast, fogbound skies of the Baltic Sea; the crumbling Gothic silhouettes of the monastery ruins at Oybin; the natural wonder of a gate of boulders in the wilds of the mountains of the Elbsandsteingebirge; even the nationalist Germanic style of dress (high-waisted, high-collared, long-sleeved dresses for women; broad velvet hats, shoulder-length hair, wide cloaks for men), which during the Napoleonic Wars was vigorously revived. For Friedrich, no fact was too humble to record, but all facts seem to radiate a symbolic power. Like a medieval artist for whom the empirical world provided keys to an eternal, truer realm that lay beyond the visible, Friedrich can persuade us that everything he depicts is charged with special significance. When he paints a pair of swans in the rushes as the sun sets, we know that he has something in mind that far transcends picture-postcard prettiness. When he rhymes the spiky twin-towered façade of the Marienkirche at Halle with a pair of equally thin and lofty masts in the adjacent harbor (Fig. 12), we know that some message is waiting to be discerned. When an empty boat seems to have been moored forever on a desolate shore in tandem with a full moon on the horizon, we sense that this fact must also be a symbol.

Friedrich's genius for translating the commonplace into what appears to be a language of uncommon meaning can be demonstrated by an almost too obvious comparison; for Manet's famous boating scene of 1874 (Fig. 13) would almost be, in terms of an impersonal description, the equivalent of Friedrich's *On the Sailboat*, 1818–19 (Fig. 14). Both offer a young couple glimpsed in the midst of what appears to be a pleasurable voyage, and both use such audacious croppings at top, side, and bottom that we become unexpected intruders in these private lives. Yet if Manet's sun-drenched

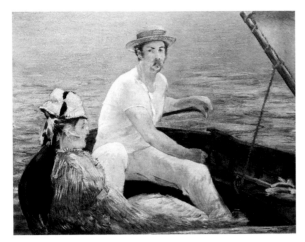

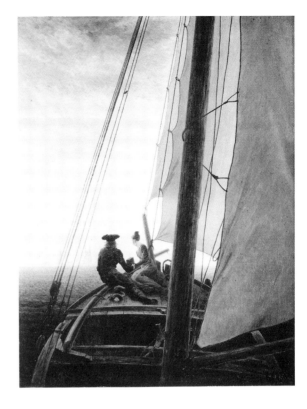

Fig. 13 Edouard Manet, *Boating*, 1874. Oil on canvas, 38¼ x 51¼ in. (97.1 x 130.2 cm). The Metropolitan Museum of Art, New York. The H. O. Havemeyer Collection, Bequest of Mrs. H. O. Havemeyer, 1929 (29.100.115).

Fig. 14 Caspar David Friedrich, *On the Sailboat*, 1818–19 (p. 48)

boating scene seizes an almost accidental moment in the momentarily shared but very separate worlds of these two summery figures at Argenteuil, Friedrich's painting instantly transcends the ephemeral and the leisurely, inviting us to invent allegorical scenarios. The extreme contrast of near and far, of the palpable wooden fact of the boat versus the distant mirage on the horizon of an enchanted city dissolved in sunlight, immediately sets into motion thoughts of life cycles, unattainable dreams, and otherworldly voyages; and the pairing of the couple, holding hands in eternal communion before this shimmering but minuscule vision, implies that this is no ordinary journey, but one in which two souls, man and wife, male and female, are forever united. Who could classify this as a mere genre scene? If we add to this pictorial mood the fact that in the summer of 1818, Friedrich and his wife of six months had traveled by land and by sea to Greifswald and to the mysterious island of Rügen, which Friedrich had often depicted before, the allegorical weight of the painting, both private and public, only increases.

Nevertheless, the degree to which we can read a clear and simple interpretation of this painting or any other work by Friedrich is a thorny topic, the subject of much recent controversy. Some Friedrich scholars, particularly Helmut Börsch-Supan,[8] would read Friedrich's art almost as if it were

a Rosetta stone, whose cryptic components, once identified in a dictionary of symbols, could spell out a single, lucid meaning. For example, the swans in the Leningrad painting (Fig. 15) are, for him, symbols of a happy anticipation of death, since swans are reputed to sing most beautifully before they die. Moreover, this swansong would be heard against a background glimmer of red sky behind the rushes—a sunrise that would finally obliterate the barely visible crescent moon and would therefore be a symbol of the Resurrection, fusing Christian and natural cycles. As for the ghostly owls that appear, along with Gothic architecture or a full moon, in two of the Leningrad drawings, they, too, represent death, whose presence evokes not only fear but also a wise awareness of the transcendental peace and wholeness death carries with it. Even the fishermen's nets, stretched out to dry for the night in the Leningrad painting, take on eschatological significance, becoming a symbol of the ceasing of earthly activities, while a flock of birds may be translated as dead souls flying toward the moon, in turn a symbol of Christ.

To be sure, many of the components of Friedrich's art long had symbolic meanings in both classical and Christian iconography and appear in many Baroque emblem books that were part of his artistic heritage. At the beginning of his career, moreover, Friedrich often explained many of his then bewilderingly original landscapes by reference to a symbolic program that identified the mystical, and usually Christian, meanings of sun and moon, rock and tree.

Nevertheless, if the meaning of Friedrich's art could be decoded that simply, we would read it only as a rebus to be solved; whereas, in fact, one of the most potent aspects of his genius is to transcend a one-to-one reading of conventional symbols, leaving the viewer free to intuit a deep resonance of potential meanings.[9] Friedrich virtually depicted this densely layered experience in the Leningrad painting of the Gothic ruins at Oybin, in which a traveler is seated on the brink of a vision of church and sunlit horizon and meditates on what we feel to be the broadest range of associations evoked by the site and the time of day. Here it is worth noting, too, that the painting of the couple in the sailboat has remained a marvel of ambiguity, with some commentators reading the glow behind the distant city as a sunrise and others, as a sunset (a typical contradiction in the Friedrich literature, as well as in his art, where even the rising of the moon and the setting of the sun may be confounded). The very identity of the couple remains uncertain, for although the woman somewhat resembles known images of Friedrich's new wife, Caroline Bommer, the man has totally concealed his face from us, preventing our reading the pair simply as a double portrait. And toward what, indeed, are they traveling? Is it the river of life, which must end in the heavenly realm of the afterlife, or is it a vision of a more earthly future happiness of a sort appropriate to any newlyweds embarking

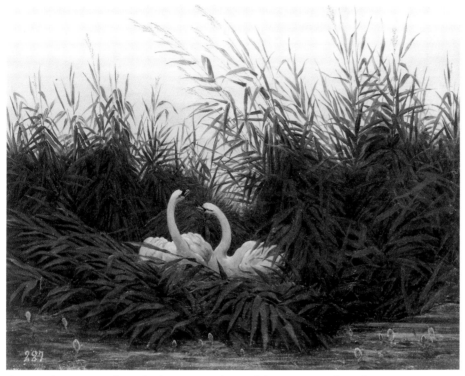

Fig. 15 Caspar David Friedrich, *Swans in the Reeds by Dawn's Early Light*, ca. 1832
(p. 72).

on their joint voyage?[10] Moreover, the distant city for which they have set sail is no less open to myriad subjective readings. Although buildings from three cities that Friedrich knew—Greifswald, Stralsund, and Dresden—have been dimly discerned in these phantom silhouettes, it is also true that the young imperial Russian couple who bought the painting— Nikolai and Alexandra—hung it in their residence in Peterhof on a wall facing the city of Saint Petersburg, so that in their mind's eye, Friedrich's painted vista across the water could easily be translated into a romantically remote view of the Russian capital to the east of their home.[11] Were Friedrich's metaphors not so susceptible to subjective readings, their reverberations would hardly be so deep and their role in establishing a more evocative language of symbolism would hardly be so central to the origins of modern art.

For in recent decades, we have become more aware of Friedrich's position as one of the earliest artists to express emotional dilemmas we recognize as belonging to our own era. He might well be credited as the first to capture the sense of total human isolation before the numbing mysteries of transitory life on earth. Even when his figures stand in pairs—as brothers, sisters, friends, or husband and wife—before awe-inspiring vistas of distant

horizons, they appear to be as immersed in solitude as Friedrich himself often wished to be. It is telling that in 1821, when his Russian friend and patron Zhukovsky suggested that they travel to Switzerland together, Friedrich politely declined, explaining that he would be terrible company, for he needed complete solitude for his dialogue with nature. Indeed, he recounted how he had once spent an entire week alone in the wild depths of the Uttewalder Grund even though he realized such isolation could pervade one's soul with gloom.[12] Such alienation—such a teetering balance between, as Kierkegaard was soon to put it, being and nothingness—had earlier been quelled by communal religious beliefs, but it would lend a new tragic and spiritual aura to post-Christian modern experience.

In narrower terms, Friedrich's shadow was immediately cast among his German and Norwegian friends and disciples (Carl Gustav Carus, Ernst Ferdinand Oehme, Carl Julius von Leypold, and Johan Christian Clausen Dahl, among others), and in Russia it can be easily discerned in the marine paintings of Ivan Aivazovsky, who, beginning in the 1830s, seems to have fallen under the spell of the master's images of the melancholy immensities of sea and sky.[13] Apart from questions of direct influence, however, Friedrich's innovations take their place as fundamental themes and structures that would later be explored by artists who probably had never heard his name or seen a single reproduction of his work. Decades before mid-century American Luminists like John Kensett or Martin Johnson Heade, Friedrich sought to cross the threshold of the supernatural by worshiping at the altar of a natural light so potent it could turn all substance into void and all time into timelessness. Long before the landscapes of such Symbolist masters as Edvard Munch and Ferdinand Hodler, Friedrich made us realize that the most lofty of mountain heights and the most remote of unpolluted shores were the proper settings for the theater of philosophical speculations, both melancholy and exalted, to be supplied by the viewer. And the ghost of Friedrich, the archetypal master of the gravity-defiant image of a luminous nothingness that can take us from matter to spirit, hovers over many domains of abstract art, down to the recent achievements of the California artist James Turrell. Now that the radiance of Friedrich's Russian paintings and drawings has crossed a continent and an ocean, at last to be seen on American shores, who can predict what future magic may emanate from his still timely vision?

NOTES

1. For a fuller account of Friedrich's Russian connections, see Asvarishch 1985.
2. See Hinz 1968, p. 236.
3. Ibid.
4. *Caspar David Friedrich, 1774–1840,* Kunst um 1800, exh. cat. (Hamburg: Hamburger Kunsthalle, 1974).
5. *Caspar David Friedrich und sein Kreis,* exh. cat. (Dresden: Gemäldegalerie Neue Meister, Staatliche Kunstsammlungen Dresden, 1974).
6. At the National Museum for Modern Art, Tokyo, and the National Museum, Kyoto.
7. *La Peinture allemande à l'époque du Romantisme,* exh. cat. (Paris: Orangerie des Tuileries, 1976).
8. Thus, in the fundamental work Börsch-Supan and Jähnig 1973, a dictionary of objects found in Friedrich's paintings is given with, in each case, its symbolic meaning (pp. 224–31).
9. The most persuasive arguments against this one-to-one reading of Friedrich's symbolism are found in Charles Rosen and Henri Zerner, *Romanticism and Realism: The Mythology of Nineteenth-Century Art* (New York, 1984), chap. 2.
10. The latter is the interpretation offered in the first serious publication of Friedrich's paintings in Leningrad: Isergina 1956a.
11. This further contextual interpretation is found in a full study of the painting: Hofmann 1988.
12. See Hinz 1968, pp. 234–35.
13. For a discussion of Aivazovsky in the context of Friedrich and American Luminism, see Theodore E. Stebbins, Jr., "Luminism in Context: A New View," in John Wilmerding, ed., *American Light: The Luminist Movement, 1850–1875,* exh. cat. (Washington, D.C.: National Gallery of Art, 1980), pp. 211–36.

Fig. 16 Anonymous, *Room in the English Cottage, Alexandria Park at Peterhof, near Saint Petersburg*, ca. 1840. Watercolor. State Hermitage Museum, Leningrad. Friedrich's *On the Sailboat*, 1818–19, hangs on the wall at the right.

Friedrich's Russian Patrons

BORIS I. ASVARISHCH

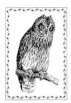 The works by Caspar David Friedrich at the Hermitage, which include a number of undisputed masterpieces, were brought to Russia during the artist's lifetime. They were specially commissioned or carefully selected directly from his studio. All of the nine paintings and six drawings in the collection, with the exception of *In Memory of the Riesengebirge* (p. 76), belonged to members of the imperial family, in whose Saint Petersburg or country palaces they remained until entering the Hermitage after 1917.

The first imperial acquisition was made in 1820, when Grand Duke Nikolai Pavlovich—the future Czar Nicholas I—visited Friedrich's Dresden studio. This visit came about not so much as a result of the grand duke's own wishes as at the prompting of his wife Alexandra Fedorovna, whose father and brother (the Prussian king Frederick William III and the crown prince, respectively)

had at one time been Friedrich's patrons and had bought paintings from him. Alexandra Fedorovna knew his work well from the Berlin Academy exhibitions and her brother's palace. It was probably at her request, then, that the grand duke bought two of the artist's paintings.

Friedrich's contacts with his Russian patrons continued until his death. A vitally important role in his dealings with them was played by the celebrated poet Vasily Andreyevich Zhukovsky (Fig. 17), who met Friedrich in 1821 and immediately recognized and appreciated the originality of the artist's personality and the exceptional qualities of his art. Their acquaintance developed into a long-standing friendship, rooted in a spiritual kinship between two Roman-

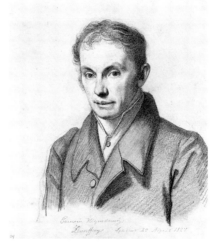

Fig. 17 Carl Christian Vogel von Vogelstein, *Portrait of Vasily Andreyevich Zhukovsky*, 1827. Chalk, white highlights, 10¹/₁₆ x 8¼ in. (25.6 x 21 cm). Kupferstichkabinett, Staatliche Kunstsammlungen Dresden (Photograph courtesy Sächsische Landesbibliothek, Abteilung Deutsche Fotothek, Dresden).

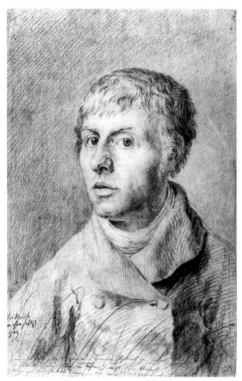

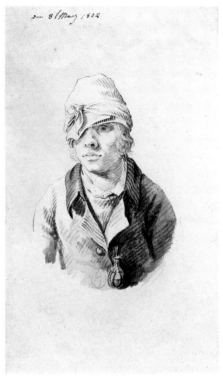

Fig. 18 Caspar David Friedrich, *Self-Portrait*, ca. 1798. Black chalk, 16½ x 10¹³⁄₁₆ in. (42 x 27.6 cm). Statens Museum for Kunst, Copenhagen.

Fig. 19 Caspar David Friedrich, *Self-Portrait with Cap and Visor-Flap*, March 8, 1802. Pencil and brown wash, 6⅞ x 4⅛ in. (17.5 x 10.5 cm). Hamburger Kunsthalle, Hamburg.

tic natures. Zhukovsky unreservedly supported and helped Friedrich during the most difficult periods of his life.

On his visits to Dresden, the poet never failed to visit Friedrich's studio. From the correspondence they maintained when apart, we know of their discussions on art, their ideas for future pictures, and their visits together to the Dresden galleries and exhibitions. We also know that Zhukovsky quickly realized that the unsociable, reserved Friedrich was all but helpless when it came to everyday affairs. His family's financial situation was often extremely strained, and Zhukovsky did all he could to help him, seizing every opportunity to arrange sales of his paintings in Saint Petersburg. Because of his special position at court (in 1817 he became Alexandra Fedorovna's Russian teacher and in 1826 was appointed tutor to the czarevitch, or heir apparent, Alexis Nikolayevich), Zhukovsky was able to do a good deal. Not only was he a trusted advisor of the imperial family, but with his gifts as a storyteller, he bewitched the recipients of his letters with poetic descriptions of Friedrich's paintings, practically willing them to see each picture in their mind's eye and to purchase it. One letter first provides a description of Friedrich himself:

There's nothing about [Friedrich] that suggests the ideal, nor did I expect to find it. Whoever knows Friedrich's misty paintings and, on the basis of these works, which show only the gloomy side of nature, expects to find in him a contemplative melancholic with a wan face and a look of poetic dreaminess in his eyes, will be disappointed. There is nothing about Friedrich's face that would make it remarkable in a crowd. He is a lean man of average height, fairskinned and with white brows drooping over his eyes. The outstanding feature of his physiognomy is its simple-heartedness, and this marks his character too. There is simple-heartedness and sensitivity in his every word; he speaks without rhetoric but with the animation of sincerity and feeling, especially when the conversation touches on his favorite subject, nature, with which he is on the most familiar of terms. But he talks about it just as he paints it, not in a dreamy way but with originality. Nor is there anything dreamy in his paintings—on the contrary, they please by their truthfulness, because each one of them awakens in the viewer's soul memories of something familiar. If you find in them more than what the eyes see, that is because the painter looked at nature not as an artist, who seeks only a model for his brush, but as a human being with feelings and imagination, who finds in every aspect of nature a symbol for the human soul. Friedrich has

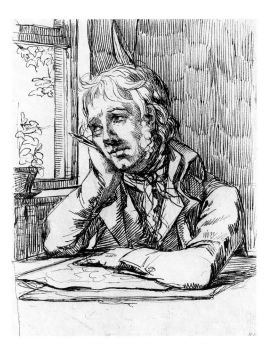

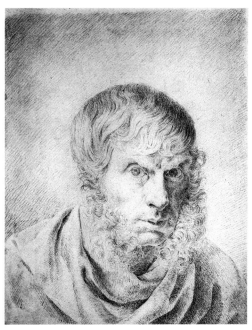

Fig. 20 Caspar David Friedrich, *Self-Portrait with Propped-Up Arm*, ca. 1802. Pencil and pen and ink, 10½ x 8½ in. (26.7 x 21.5 cm). Hamburger Kunsthalle, Hamburg.

Fig. 21 Caspar David Friedrich, *Self-Portrait*, ca. 1810. Chalk, 9⁹⁄₁₆ x 7⅛ in. (23 x 18.2 cm). Nationalgalerie, Sammlung der Zeichnungen, Staatliche Museen zu Berlin.

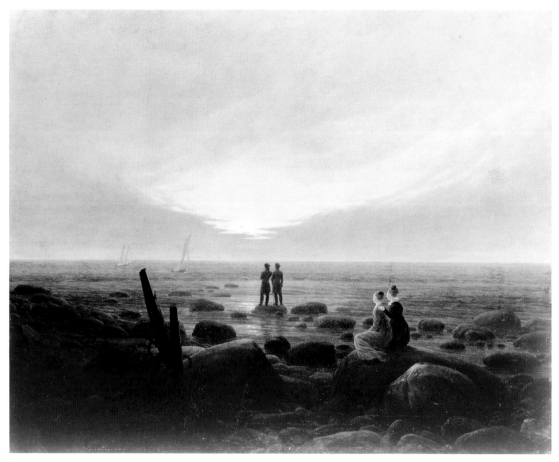

Fig. 22 Caspar David Friedrich, *Moonrise by the Sea*, 1821 (p. 56).

little time for the rules of art; he paints his pictures not for art connoisseurs, but for the friends of nature, his model. The critics may be dissatisfied with him, but that finest of critics, unbiased feeling, is always on his side. He is an equally fine judge of paintings by other artists. On several occasions, I accompanied him to a gallery. As he looked at the many paintings there, he was unable to tell me the artists' names, and in general knew little about all those things that are mentioned in painting textbooks. Yet in many pictures he found attractions or flaws such as could only be detected by one who had looked into the textbook of nature.

Zhukovsky goes on to describe Friedrich's current work:

In his studio I found several paintings he had begun, one of which you would really have liked to have [Fig. 22]. It could serve as a pendant to the one you already own. It shows a moonlit night; the sky is stormy but the storm has passed, and all the clouds are scudding to the distant horizon,

Fig. 23 Detail from Caspar David Friedrich,
Moonrise by the Sea, 1821 (p. 56).

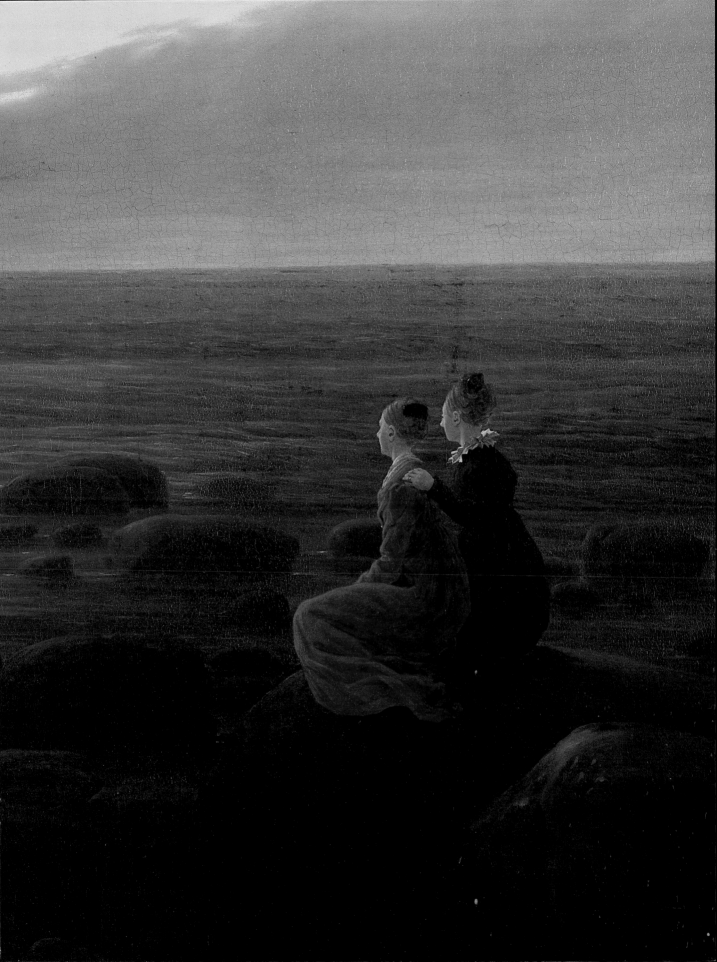

leaving half of the sky completely clear. The moon stands above the clouds, and their edges are lit by its glow. The sea is calm, the low shoreline sprinkled with rocks, but there is an anchor on the shore. In the distance, at the very edge of the sea, one sees the sail of a ship speeding toward the shore (it is bringing back to their homeland all those who are leaving it in your picture). There are people waiting for them. Two young women are sitting on the rocks, watching the distant sail with calm hope. Two men, less patient in their hope, have jumped over the first rocks and are standing a few paces closer to the ship. Before them is the water, and they are gazing into the distance. There are several more rocks in front of them, but they are too far away to reach. This painting is just begun, but the drawing is splendid, simple and expressive. It is twice as large as yours. I inquired about the price—100 chervontsy. Friedrich is now working on a commission for someone who wants two paintings, one depicting the nature of the South with its opulent and majestic charm, the other the nature of the North in all its horrific beauty. Friedrich has agreed to paint the second scene, but he doesn't yet know himself what he will paint. He is waiting for the moments of inspiration that, he says, sometimes come to him while he's asleep. Sometimes, he says, I think and not a thing occurs to me! But then I'll happen to fall asleep and suddenly, it's as if someone had woken me up. I leap up, open my eyes, and whatever I am searching for is there before my eyes like an apparition. Then I grab a pencil, and the main part is done.

The poet then relates how Friedrich declined to accompany him on a trip to Switzerland:

My acquaintance with Friedrich came about so quickly and he seemed such a kindred spirit, that I suggested we travel together to Switzerland—I had enough money for the both of us. But he refused, and his manner of refusing made me like him even more than before. "You want me to go with you," he said in reply, "but the side of me that you like won't be there with you! I have to be alone and know that I am alone if I am to examine nature closely and experience her completely. To be what I am, I must devote myself to the world around me, become one with my clouds and cliffs. Solitude is essential to my conversation with nature. Once I happened to spend a whole week in the Uttewalder Grund among the cliffs and fir trees, and in all that time I didn't meet a single soul. True, I wouldn't recommend such a method to anyone, and even for me it was too much. Despite yourself, your spirits become gloomy. But this should just prove to you that my company is incapable of pleasing anyone![1]

On each of his trips to Germany, Zhukovsky gave Alexandra Fedorovna detailed reports of his meetings with Friedrich:

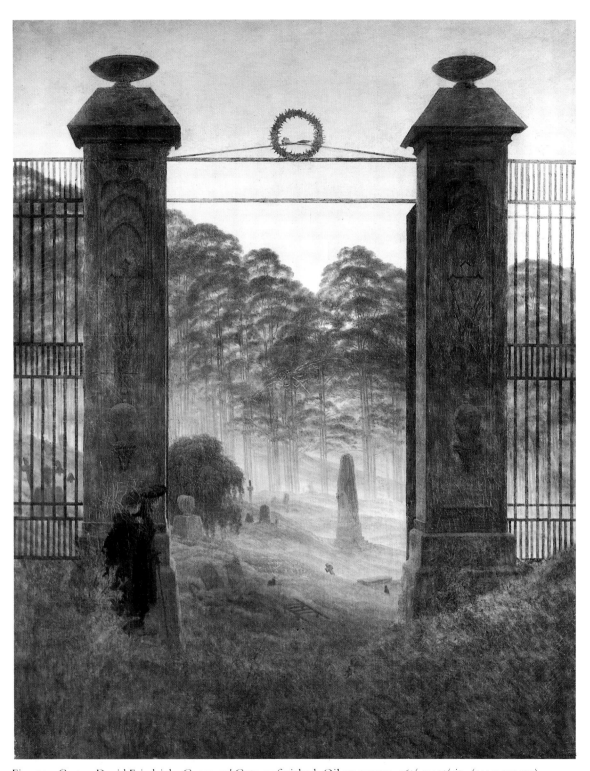

Fig. 24 Caspar David Friedrich, *Graveyard Gate*, unfinished. Oil on canvas, 56¼ x 43¼ in. (143 x 110 cm). Gemäldegalerie Neue Meister, Staatliche Kunstsammlungen Dresden.

I see the artist Friedrich here from time to time. There is nothing of particular interest in the way of paintings in his studio, but he has just begun a large landscape [Fig. 24], which will be charming if the execution does justice to the idea. A big iron door leading to a graveyard stands open. Near this door, in its shadow, a man and woman can be seen leaning against one of its columns. They are a married couple who have just buried their child, and in the general gloom they can see his grave, which is barely discernible in the depths of the graveyard. It is just a mound on the grass with a shovel lying alongside. Not far from this grave you see another with an urn towering above it, where the remains of the child's ancestors lie. The graveyard is full of pine trees. It is nighttime, and though the moon is not visible, the scene is lit by its light. A tremulous gloom passes over the graveyard, blotting out the roots of the pines so that they seem to have risen above the ground. Through this veil one can just make out the other graves and especially their simple rural headstones. A tall stone, which has been stood firmly on its end, looks like some gray apparition. Altogether it is a delightful landscape. But the artist had a more lofty idea in mind; he wanted to turn our thoughts toward the future life. The bereaved parents remain in the graveyard doorway. Their gaze, turned toward the grave of their child, is caught by some mysterious vision. And indeed, the wavering mist that envelops the place seems to be alive. They imagine that their child is rising out of the grave, that the shades of his forebears are coming toward him, with arms outstretched, and that the angel of peace with his olive branch hovers over them and unites them. None of these ethereal creatures can be made out clearly; only the mist is visible. But one's imagination fleshes out the artist's suggestion, and this vision, while not actually adding anything to the simple landscape, serves only to increase its naturalness.[2]

One may easily imagine that such penetrating descriptions had the desired effect. Naturally, they were followed by new commissions and sales. Over the years, the money sent from Russia became essential to Friedrich to make ends meet, the more so since he was able to find fewer and fewer buyers in Germany. The last purchases that the Russian court made were also mediated by Zhukovsky following his last visit to Friedrich's studio in March 1840, shortly before the artist's death.

In December 1841, Friedrich's widow approached Zhukovsky with a fervent plea to Nicholas I for assistance. On this, as on previous occasions, the poet exerted himself on the artist's behalf, writing to Alexandra Fedorovna in 1843:

While I was with Your Imperial Highness in Dresden, I visited the painter Friedrich. I found him incapacitated by paralysis. He felt he had not long to

*live and cried like an infant as he spoke these words: "The Russian emperor
visited my atelier when he was still heir to the throne. He was extremely
gracious to me and told me, 'Friedrich, if you are ever in need let me know. I
won't abandon you.' So here I am now in great need, I can't hold a
paintbrush, I'm about to die. My family will be destitute." Later that year
Friedrich died. Recently I received a letter from Saint Petersburg [Caroline
Friedrich's request for assistance], which I now enclose. It had arrived there
during my absence and had been lying around for an entire year. I was
therefore unable to bring its contents to the attention of the emperor. . . . I
implore Your Imperial Majesty to show my note and the attached letter to
the emperor. If His Highness feels kindly disposed to assist Friedrich's wife
and children in some way, our ambassador to the Saxon court will locate
them in Dresden. For that matter, I too could carry out His Imperial
Majesty's wishes.*[3]

Alexandra Fedorovna complied with Zhukovsky's request and gave the letter
to Nicholas I. Zhukovsky reported the outcome to the envoy in Dresden: the
emperor "desired that two paintings by Friedrich be purchased but did not
remember promising him anything in his time of need."[4] Nevertheless,
Friedrich's family received at the same time the modest sum of 150 thalers—
the price of a medium-size painting.

Over a period of twenty years, paintings and drawings arrived regularly
at the court from Dresden. It is probably impossible to say exactly how many,
but to judge from the correspondence, documents, and memoirs, there were
originally a good many more works by Friedrich in the Saint Petersburg and
country palaces than have come down to us today.

No less grievous a loss was the disappearance of Zhukovsky's personal
collection. Although not a wealthy man, he did have easy access to Friedrich's
paintings, and since they were relatively inexpensive, he permitted himself to
purchase some of them. Today his collection would be the envy of any mu-
seum, since it included a minimum of eight paintings and fifty drawings.
Through a detailed description written in 1830 by the well-known journalist
and literary figure Ivan Kireyevsky, we know something about the paintings
that hung in Zhukovsky's apartment and astonished his friends:

*I would like to describe . . . the room, because it made a powerful impression
on me on account of the paintings. . . . On one side there are two windows
and a mirror. . . . On the other hang the paintings by Friedrich. In the
middle [of one side of the room] there is a large painting of a night scene,
with the moon and an owl above it. From the angle of the bird's flight, we
are able to see what she sees. The arrangement of the entire painting
bespeaks the soul of a poet. Flanking the owl picture are two small square
canvases. One was a gift from [statesman and historian] Alexander*

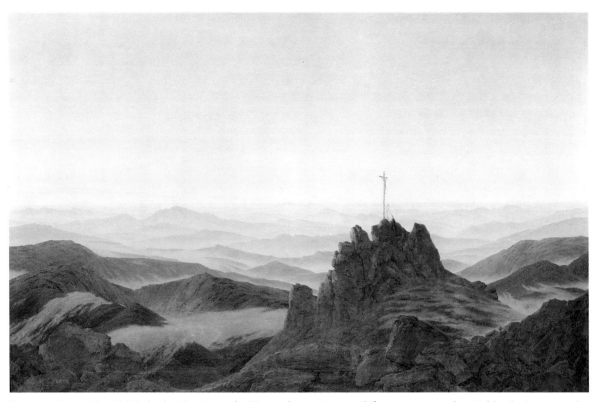

Fig. 25 Caspar David Friedrich, *Morning in the Riesengebirge*, 1810–11. Oil on canvas, 42½ x 66⅞ in. (108 x 170 cm). Verwaltung der Staatlichen Schlösser und Gärten, Schloss Charlottenburg, Berlin.

Turgenev, who had personally commissioned it from Friedrich. It shows a distant prospect, the sky and the moon. In the foreground there is a railing on which three men are leaning their elbows—the two Turgenev brothers and Zhukovsky. Zhukovsky told me this himself, explaining that two of them had buried the third together. The second painting shows a night scene, the sea, and the wreckage of three anchors on the shore.

In the third [fourth?] picture, Friedrich has painted an evening scene just after sunset, with the West still golden. The rest of the sky is a tender azure that melts into a mountain of the same color. In the foreground is a stand of thick tall grass in the midst of which lies a gravestone. A woman in a black dress and a shawl approaches it and seems afraid that someone will see her. I liked this painting more than the others. The fourth [fifth?] painting shows a Jewish grave, an enormous stone resting on three smaller ones. . . . All is deserted and cold looking. The green grass bends in the wind, and the sky is gray and dotted with clouds. The sun has already set, and here and there the clouds still reflect its last flickering rays. This canvas occupies the second wall opposite the doors. On the third wall, there are four more paintings by Friedrich. One depicts what seems to be an autumn day,

with green grass beneath and above the bare branches of trees, a gravestone, cross, summerhouse, and cliff. All is dark and wild. In general Friedrich's depiction of nature is gloomy and always solitary. This is the island of Rügen, where he lived for many years. The second picture shows a crumbling stone wall, above which the moon can be seen rising through a narrow gap. Beneath, through the gateway, one gets a faint glimpse of a landscape consisting of trees, the sky, a mountain, and foliage. In the third work, a huge wrought-iron railing and gates open onto a graveyard that is overgrown with thick, impenetrable grass. The fourth painting consists of arch-shaped ruins framing a column against which a woman is leaning. She stands with her back toward us, but it is clear from her pose that she has been there a long time lost in thought, perhaps looking at something, or waiting, or just thinking. All of this passes through one's mind and gives the painting an extraordinary charm.

A selection of extracts from Zhukovsky's letters to his friends in Dresden gives a fairly accurate picture of his purchasing activities: "I beg you to tell Friedrich . . . that I hope to acquire from him two pictures every spring, of the same size as those I have already purchased" (1827). "I beg you also to meet with Friedrich and tell him not to forget his promise to send me every spring two paintings of the size we had agreed on, or else one twice the size. He promised me he would paint the four times of the day, but the rest I leave to his taste—he knows mine well enough" (1828). "I received your letter with Friedrich's note attached. In it he describes the paintings that are finished. . . . I can take only two of them. Select the best. But if you find something he has just completed, do take a look at it" (1829). "Many thanks for your letter concerning Friedrich. I've already written to him twice and specified what he is to send" (1835). "When you see Friedrich, tell him from me that I have received his drawings and am absolutely delighted with them" (1836).

One letter that has not been included before in the literature on Friedrich, written by one of Zhukovsky's closest friends, Alexander Turgenev, gives an account of a call on the artist in 1827 and a description of some of several works then commissioned by the poet: "Among the subjects he suggested were death at a graveside and another showing life. Another idea was a cemetery where flowers bloom amidst the rural headstones and the thick grass grows green and full of life. In yet another, deep snow covers the graveyard, a dead tree reminds us again of death, and close by, a snowdrift has been dug up for the grave and the spades lie half buried in snow. All has lived and blossomed, only to die."[5] Although all the subjects that Zhukovsky suggested were probably not carried out, it is notable that they were in keeping with Friedrich's own formal vocabulary and that the artist accepted

them without protest. The poet's own drawings are a remarkably vivid testament to the two friends' very similar view of the world around them. Zhukovsky was an enthusiastic and prolific draughtsman, and more than fifteen hundred of his drawings have survived. The majority of them were made on his travels, when he would fill the pages of albums with landscapes, figures, and typical scenes, as if illustrating and fleshing out the notes in his diary. The source for Zhukovsky's compositions is not hard to find: his understanding of space and his clear, well-defined use of line are both indebted to Friedrich, whose style he frequently and frankly copied.[6]

Friedrich reached maturity as an artist during a time of transition, when the systems of the old epoch were crumbling and giving way to the new directions of nineteenth-century art. Friedrich was among those artists who consistently disassociated themselves from outmoded traditions during this turbulent period and boldly embraced new artistic problems.

Few of his contemporaries were able to understand his vision, however. During a very brief period in Friedrich's lifetime, his paintings found favor at the Berlin and Dresden Academy exhibitions and even found buyers in circles to which he did not belong, but these patrons admired only what was obvious to a superficial observer. This response is evident in Frederick William III's remarks concerning a Friedrich landscape he bought in 1812, *Morning in the Riesengebirge*, 1810–11 (Fig. 25): "This is a splendid picture. When I was traveling in Teplitz, I used to get up early and admire this captivating locale. The towering mountaintops were like the surface of the sea. . . . Anyone who had never seen such a sight would think it didn't exist." It is no coincidence, then, that when recommending a purchase of one of Friedrich's works, Zhukovsky stressed precisely that quality most likely to impress his reader, Alexandra Fedorovna: "His paintings have nothing dreamlike about them; on the contrary they please because of their truthfulness."[7]

Nevertheless, buyers were already turning away from Friedrich's work by the end of the 1820s. The public demand for an art that provided a literal transcription of reality, "ennobled" by a light veneer of dreamy melancholy, was then perfectly satisfied by the artists of the Düsseldorf school. Compared to their paintings of unambiguous and easily understood literary subjects, Friedrich's works began to seem overly abstract, overburdened with a frightening mysticism that was ill suited to the decor of a bourgeois interior.

The considerable innovations of Friedrich's art did not go unnoticed, however. During his lifetime, those severe and uncompromising critics who defended the unshakable, time-honored rules and regulations of art did not admire his originality. The following words were written in 1808 by the

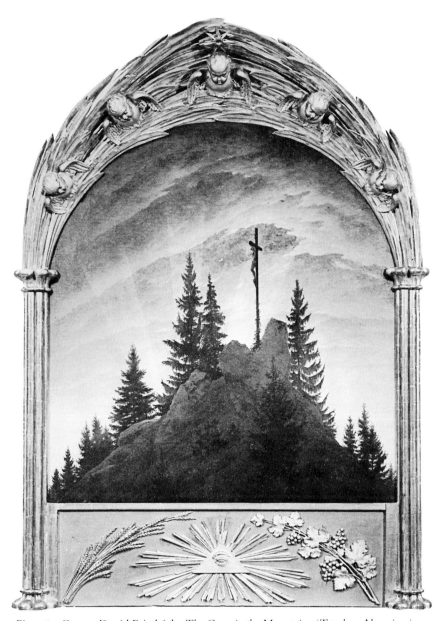

Fig. 26 Caspar David Friedrich, *The Cross in the Mountains (Tetschen Altarpiece)*, 1807–8. Oil on canvas, 45¼ x 43½ in. (115 x 110.5 cm). Gemäldegalerie Neue Meister, Staatliche Kunstsammlungen Dresden.

art historian Basilius von Ramdohr about the painting *The Cross in the Mountains (Tetschen Altarpiece)*, 1807–8 (Fig. 26), which caused a public scandal because of its unusual treatment of a religious theme: "Friedrich's picture deviates from the usual path. It opens a new, hitherto unknown, at least to me, notion of the art of landscape. . . . And when I see talent submitting itself to a tendency that violates good taste, that robs painting, especially landscape painting, of its specific excellence, that is nothing other than an

abominable testimony to the calamitous spirit of the present times—then to keep silent would be cowardly."

Goethe, who initially supported Friedrich (it was through that poet's intervention that two of the artist's sepias won prizes at an exhibition in Weimar in 1805, and on his recommendation that the duke of Weimar bought Friedrich's paintings), became irritated by the way that artists were over-turning what for him were venerable idols and described *The Monk by the Sea*, 1809–10 (Fig. 27), as a painting that "could be looked at standing on one's head." This comment anticipated a criticism leveled at abstract artists more than a hundred years later—the objection that there was no up or down in their paintings. Thus, the great Goethe perceived in Friedrich's work the abstract quality that would lead twentieth-century scholars to seek in Romanticism some of the roots of modern art.

Even in 1841, when the triumph of the Düsseldorf school's principles was at its height, Hippolyte Fortoul could record the following response to one of Friedrich's paintings, which he viewed in the Dresden Academy shortly after the artist's death: "We have before us a daring protest against literal

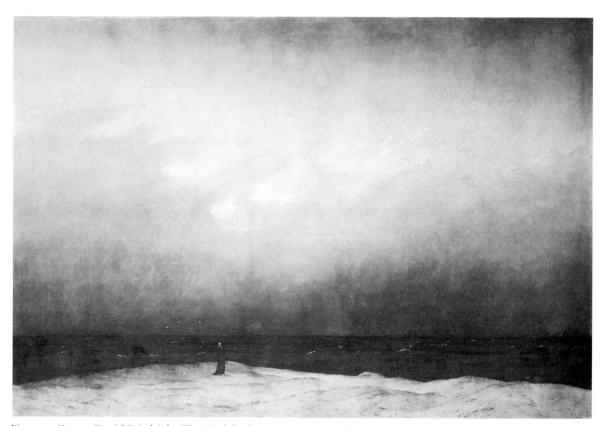

Fig. 27 Caspar David Friedrich, *The Monk by the Sea*, 1809–10. Oil on canvas, 43¼ x 67½ in. (110 x 171.5 cm). Nationalgalerie, Staatliche Museen Preussischer Kulturbesitz, Berlin.

imitation and copying."[8] Fortoul echoed the painter's own comment that "a painting should be seen as a painting, as something created by human hands and not a deceptive, total copy from nature."

With few exceptions, Friedrich painted only landscapes, and these were for the most part specific locations in his native Germany, places he had seen and knew. This in itself was sufficient to earn him the right to an original and independent vision. "For our gentlemen art judges," wrote Friedrich, "our German sun, moon, lakes, and rivers are not enough. It should all be Italian if it is to lay claim to greatness and beauty." To a certain extent, his focus on German landscape was prompted by the surge of patriotism that gripped the country at the height of the Napoleonic Wars. Nevertheless, Friedrich's conscious self-restriction to a single genre cannot be explained exclusively by his personal sympathies or antipathies toward any particular category of painting: the reasons ran deeper, and they have to do with the innovative nature of his art.

In the nineteenth century, the official academic system kept a tight rein on all pronouncements regarding the visual arts. It was the Academy alone that could make an artist's reputation and handled both the selection of paintings for exhibition and the order in which they were hung. Moreover, the Academy formulated the aesthetic views of the consumers who commissioned and bought art, inevitably dooming all artists whose ideas did not coincide with its own to an impecunious and beggarly existence, as is sadly confirmed by Friedrich's life and the fate of the Impressionists.

In the academic system of values, a painting's merit was measured by the grandeur of its subject. A scene from the Bible, history, or the classics, or a state portrait was deemed appropriate, but landscape painting (as an independent genre) occupied one of the lowliest positions. In the eyes of the Academy, landscape lacked a specific content or subject. At the same time, it was less regimented than other genres, although certain norms were still fairly stringently applied. Landscapes had always been painted in large numbers, their existence was tolerated, and they were even admitted to exhibitions and museums, but only in one of two forms: the conventionalized form of the so-called idealized landscape, purged of the imperfections of lowly and crude nature; or as an exercise for dilettantes, a kind of charming bagatelle unworthy of a serious critic's attention. As a result, landscape painting remained on the periphery of the Academy's jealously guarded territory. It was natural, therefore, that innovative ideas were able to infiltrate this genre with relative ease and that the greatest achievements of nineteenth-century painting belonged to painters of landscape.

Two of the unshakable cornerstones of academicism—classical linear perspective, which creates an illusion of space, and chiaroscuro modeling, which fills that space with plastic volumes—were modified by the explora-

tions and discoveries of artists in the nineteenth century. Henceforth, it was no longer illusionistically rendered space and mass that defined the emotional and thematic structure of an artist's work, but line and color.

Just as in music an instrument performs a specific part that merges into a unified sound, so in Friedrich's landscapes color and line play their own specific roles in creating a Romantic image. His rigorous, impeccably precise draughtsmanship, with its emphasis on contours, gives his painting a convincing sense of physical reality. The details with which he constructs this visually accessible world are painstakingly rendered and are so true to nature as to deceive an unsuspecting eye. Yet this is a Romantic, not a naturalistic, rendering of nature that only appears to be accurate. On closer inspection, we understand that Friedrich's paintings do not reproduce reality but signify it by revealing something far more general, characteristic, and essential than a mere literal copy.

In composing his paintings as graphic planes, Friedrich was able to achieve an extraordinary illusion of space. He avoided the rationalism of classical landscape by rejecting the traditional method of breaking the canvas surface into planes united into a plastic unity. At times the artist produced fragmentary compositions of amazing daring (such as *On the Sailboat,* 1818–19, p. 48) that even surpassed the achievements of Impressionism.

Finally, we turn to color, which bears much of the emotional weight in Friedrich's paintings. As he said of one work: "Here I have expressed in images and colors that which words cannot convey." In Friedrich's use of color, he again breaks with the art of the past. Color no longer creates an illusion of light that causes figures and objects to cast shadows and obey the laws of chiaroscuro modeling, nor does it convey the illusion of surface textures. For him, color is neither subordinate to drawing nor made to coincide with it; in other words, he utilizes the direct impact of the color patch itself. Indeed, his very choice of subject—whether moonlit night, sunset, or morning—calls for a single dominant tonality that sometimes borders on monochrome, as in *Sisters on the Harbor-View Terrace (Harbor by Night),* ca. 1820 (Fig. 29). Color also has associations that harmonize with such Romantic symbols as the ocean, ships, anchors, ruins, owls, or a cross on a grave. All of these aspects of Friedrich's treatment of color give his paintings their extraordinary musical quality, which prompted the German musicologist Ludwig Just to compare a night landscape by the artist with Beethoven's "Moonlight Sonata."

Characterized by restraint and the absence of exterior movement, Friedrich's works are free of direct displays of feeling. His only protagonist is the contemplative individual excluded from everyday reality and dreaming of universal harmony; remaining at one with nature, he is always shown from the back, with gaze directed toward an infinite distance.

34

Fig. 28 Detail from Caspar David Friedrich, *On the Sailboat,* 1818 (p. 48).

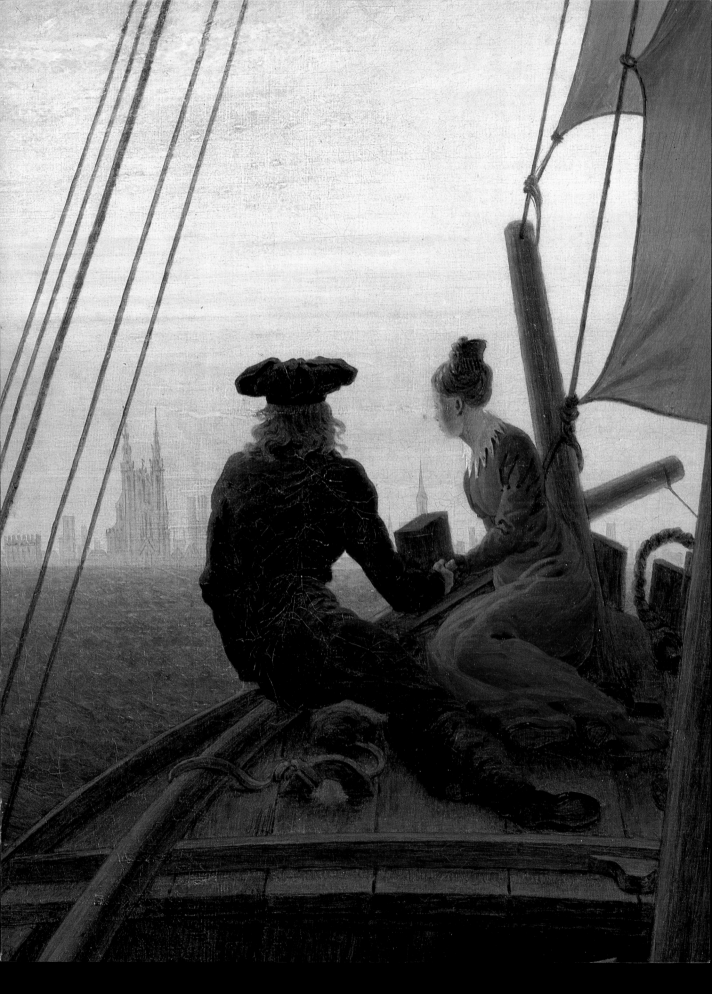

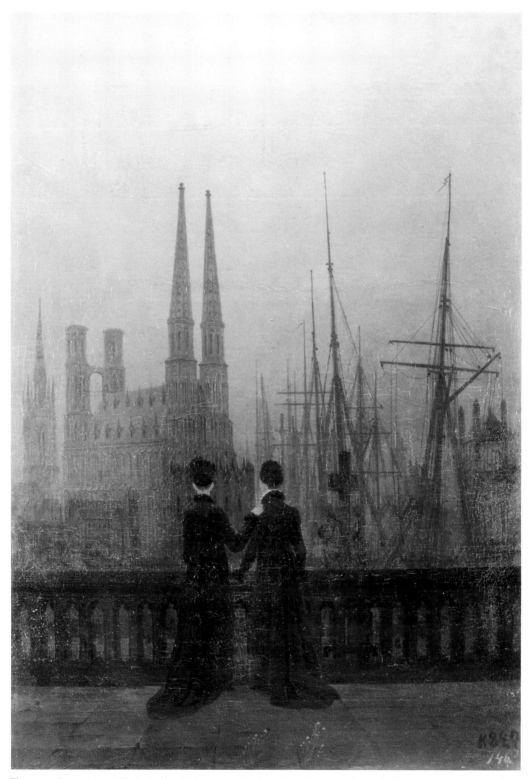

Fig. 29 Caspar David Friedrich, *Sisters on the Harbor-View Terrace (Harbor by Night)*, ca. 1820 (p. 52).

Friedrich's range of subjects was limited to a handful of themes—sea, mountains, moonlight, times of the day, graveyards, owls, ruins, windows—to which he constantly returned. Some of these themes are present in three of the paintings in the Hermitage—*On the Sailboat* (p. 48), *Sisters on the Harbor-View Terrace (Harbor by Night)* (Fig. 29), and *Moonrise by the Sea*, 1821 (Fig. 22)—which were painted between 1818 and 1821, the happiest period of Friedrich's life. They reflect the artist's memories of a trip he took with his wife six months after their marriage to his birthplace, Greifswald, whence they continued, with his brother and sister-in-law, to the island of Rügen. During that summer of 1818, the pages of Friedrich's travel album were filled with quick sketches of ideas for compositions and careful pencil studies of particular details—ships at sea, sails, masts, a figure at the prow of a rowboat. Later, Friedrich drew upon these drawings very freely, without reference to their original context, and sometimes they would reappear many years later, in combination with several others.

In the case of *On the Sailboat*, Friedrich used his sketches immediately, on his return to Dresden. For the first time, the circumstances of his everyday life proved to be in harmony with his spiritual life. The result was one of Friedrich's most radiant paintings, whose two protagonists surely contain reflections of the artist and his wife. The picture is not a self-portrait in the traditional sense of the word, however, but a portrait of the artist's mental state. The composition of the work, with the deck cropped by the lower edge of the canvas, does not make us feel like fellow passengers and witnesses to the happiness of the young couple; if this were the case, then the painting would be just a genre piece, alien to the spirit of Romanticism. Instead, the yawning foreground, the highly detailed rendering of the rigging, and the lifted prow of the boat cutting across the line of the horizon all form a dramatic contrast to the ethereal, mist-draped shore and the very sketchily drawn sea. What we see before us is not simply a boat slipping through the sea but a Romantic dream—a ship of the air, hovering above the surface of the ocean.

The cult of Romantic friendship was represented in many of Friedrich's works, usually in the form of two male figures, as in *Evening Landscape with Two Men*, ca. 1830–35 (p. 74), and *Moonrise by the Sea*. The 1818 trip to Rügen brought together four intimately connected people, all of whom were later to figure in the artist's paintings as manifestations of Romantic friendship.

Sisters on the Harbor-View Terrace (Harbor by Night) was completed in 1820 and shown at the Dresden Academy exhibition that autumn. Usually the artist confined himself to neutral titles, but in the catalogue the painting appeared as *Sisters on a Balcony in a Harbor. Night Under the Light of the Stars*, a title that points to the spiritual bond uniting the two standing female

figures. Without reference to the trip of 1818, the true meaning of this motif, unique in Friedrich's oeuvre, would remain unclear, for the two women are Friedrich's own wife and the wife of his brother.

In several subsequent paintings, Friedrich made references to his 1818 trip. There are undoubted overtones, for example, in *Chalk Cliffs on Rügen*, 1818–19 (Fig. 30), and *Moonrise by the Sea*, so eloquently described by Zhukovsky in the letter to Alexandra Fedorovna quoted above. From that account, which was informed by the poet's conversations with Friedrich, it is clear that the artist conceived of the three paintings as a single, unified exploration of an image and that he intended them to hang together. The last of the three held the greatest significance for Friedrich, as can be seen by its size; this picture and *Morning in the Mountains*, 1822–23 (p. 60), the same size, are the largest of his surviving works. The three paintings comprised an innovative form of Romantic cycle in the typically German form of a triptych. For full effect, all three parts had to be seen together.

Like the ocean, mountains were a constant motif in Friedrich's art, and he repeatedly expressed his admiration for the boundless grandeur of nature in his numerous mountain landscapes.[9] These pictures were composed from a variety of sketches, of the utmost fidelity to nature, that Friedrich had made over a number of years and from various points of view. For all their apparently faithful rendition of landscape, however, they have a peculiarly fantastic quality, and it would be impossible to make topographically correct maps from them. "When an artist wishes to deceive us by literally imitating nature, as if usurping the functions of God the Creator, he remains a mere oaf," the artist wrote. "But if he aspires to noble truth in his communication of unattainable nature, then he is worthy of respect."

Friedrich's first mountain landscapes were painted at the beginning of the century and his last—*In Memory of the Riesengebirge* (p. 76)—in 1835. Though seriously ill and partially paralyzed when he painted the 1835 picture, the artist had not yet lost his professional skill, his penetrating eye, and the freshness of his Romantic vision. The work is a pivotal one in the dating of Friedrich's oeuvre. He never signed or dated his paintings, nor do his preparatory drawings help us to date his works, as is the case with other artists. Friedrich's style of painting had fully developed by 1810 and scarcely changed thereafter. The only clues we have in dating his works are their emotional tone and their subject matter.

In Memory of the Riesengebirge is permeated with a feeling of infinite aloneness. Never before in Friedrich's works had nature been so estranged and distant from man, even hostile to him. Very different is the state of mind expressed in *Morning in the Mountains*. The soft light of early morning muffles the sharp contours of the mountain peaks. The figures of the shepherds, at first barely discernible, lend the painting an air of elegiac sadness.

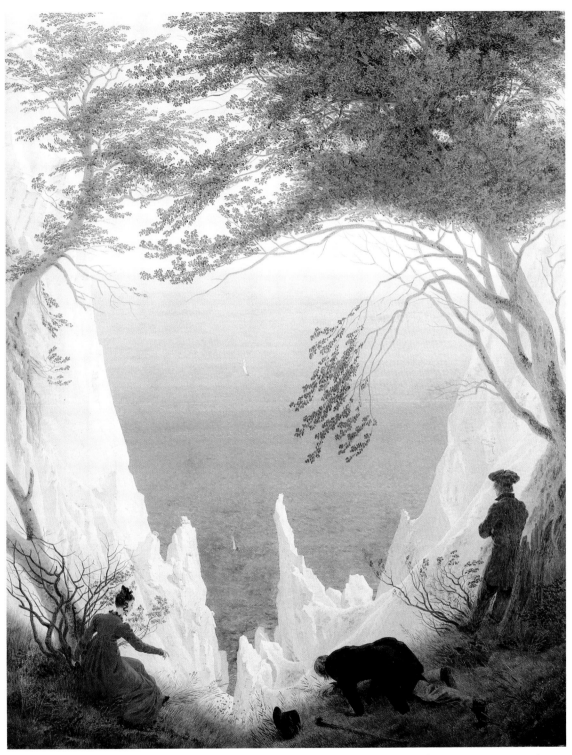

Fig. 30 Caspar David Friedrich, *Chalk Cliffs on Rügen*, 1818–19. Oil on canvas, 35⅝ x 28 in. (90.5 x 71 cm). Museum Stiftung Oskar Reinhart, Winterthur, Switzerland.

The Romantic rejection of everyday life's prosaic aspects was not necessarily at odds with Friedrich's study of his craft. "You cannot express your feelings, your sensations in images and colors, either by study or by a cunning hand," he stated, but he went on to acknowledge the importance of technique: "But you can and must practice your craft, which constitutes a lower order of art." He learned the basics of his craft at the Copenhagen Academy of the Arts, which was considered the most authoritative of such institutions in Northern Europe in the late eighteenth century.

Friedrich's irreproachable skill and manual dexterity are especially evident in his sepia drawings, which he made throughout his life. It was the sepias that brought him his first exhibition successes, and he chose this medium for his last works. For Friedrich the expressive power of a sepia drawing equaled that of any oil painting, and he explored the same motifs in both media. Unlike his drawings from life or his pen sketches, his sepias were independent works. Covering his preparatory pencil drawing with a thin layer of color, he attained amazing painterly effects of brown gradations ranging from a dark, almost black shade to a transparent light tone that faded to the white of the paper.

Friedrich's reputation today, at last in a league with those of the great masters of the past, is hardly a mere whim of changing fashion. Like no other artist of his time, he expressed the very essence of the Romantic epoch.

NOTES

1. Letter of June 23, 1821. This frequently quoted letter was first published in book form in Zhukovsky's collected works (1878). (Zhukovsky had published it earlier, in 1827, in his account of his travels in Saxony for the newspaper *Moscow Telegraph*.) In the book version, the author's personal appeal to Alexandra Fedorovna was removed and a number of colorful details added. They are included here. The letters are available in German: see Hinz 1968, pp. 233–37. All quotations in the text from any Zhukovsky letters are translations from the Russian by Wendy Salmond.

2. Letter of Oct. 2 and 14, 1826. This letter particularly affected Alexandra Fedorovna because one of her children had been stillborn.

3. This new archival material has been published in Iu. Tarasov, "Kaspar David Fridrikh. K 200-letiiu so dnia rozhdeniia" [Caspar David Friedrich. For the bicentary celebration of his birthday], *Iskusstvo*, no. 9 (1974): 59–63.

4. Ibid.

5. Letter of Jan. 28, 1827. *Pis'ma A.I. Turgeneva k N.I. Turgenevu* [Letters of Alexander Turgenev to N. I. Turgenev] (Leipzig, 1872), pp. 12–13.

6. Hermitage archives, Op. 1, 1840, d. 35, l. 13.

7. Letter of June 23, 1821.

8. H. Fortoul, *De l'art en Allemagne*, vol. 1 (Paris–London–Saint Petersburg, 1841), p. 516. Translation here by Wendy Salmond.

9. Friedrich would have agreed with Emerson's words: "Nature reveals its charms to man if man's thoughts are worthy of her grandeur."

Fig. 31 Christian Friedrich, after a drawing by Caspar David Friedrich, *Boy Sleeping on a Grave*, ca. 1803. Woodcut, 3 x 4⁷⁄₁₆ in. (7.7 x 11.3 cm). The Metropolitan Museum of Art, New York. Harris Brisbane Dick Fund, 1927 (27.35).

CATALOGUE

Window with a View of a Park
Fenster mit Parkpartie

ca. 1806–11 or 1835–37
Pencil and sepia; 15⅝ x 12 in. (39.8 x 30.5 cm)
State Hermitage Museum, Leningrad. Inv. no. 43909.
Acquired after 1917

The river Elbe flowed by Friedrich's house in Dresden, and in two drawings of 1805–6 (Figs. 32, 33) he recorded the views from his two studio windows, taken at slightly different angles. One view faces upriver and the other straight ahead. In both, the large open window is the sole motif, to the exclusion of any figures. The evocative power of the image, novel at the time, greatly appealed to Friedrich's followers, who adopted it as a stock item of Romanticism.

The stark simplicity of this frontal view through a closed window relates it to the two 1805–6 drawings. It presents a section of a park with tall poplars and other large trees. The façade of a fine, two-storied building appears on the left, and a smaller house with closed shutters and a high tiled roof is barely visible on the right.

Much deep meaning has been read into the fact that Friedrich relegated the two potted plants to the outside—something any sensible housekeeper would do to avoid removing the pots each time

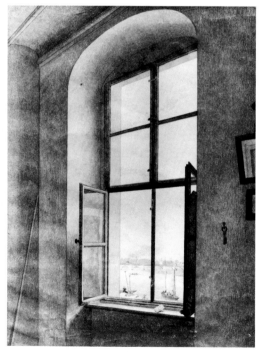

Fig. 32 Caspar David Friedrich, *View from the Artist's Studio, Window on the Left*, ca. 1805–6. Pencil and sepia, 12¼ x 9½ in. (31 x 24 cm). Kunsthistorisches Museum, Vienna.

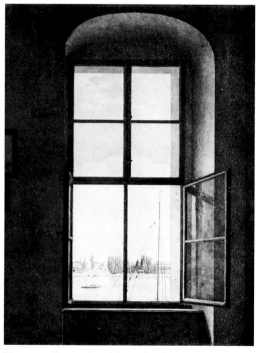

Fig. 33 Caspar David Friedrich, *View from the Artist's Studio, Window on the Right*, ca. 1805–6. Pencil and sepia, 12¼ x 9½ in. (31 x 24 cm). Kunsthistorisches Museum, Vienna.

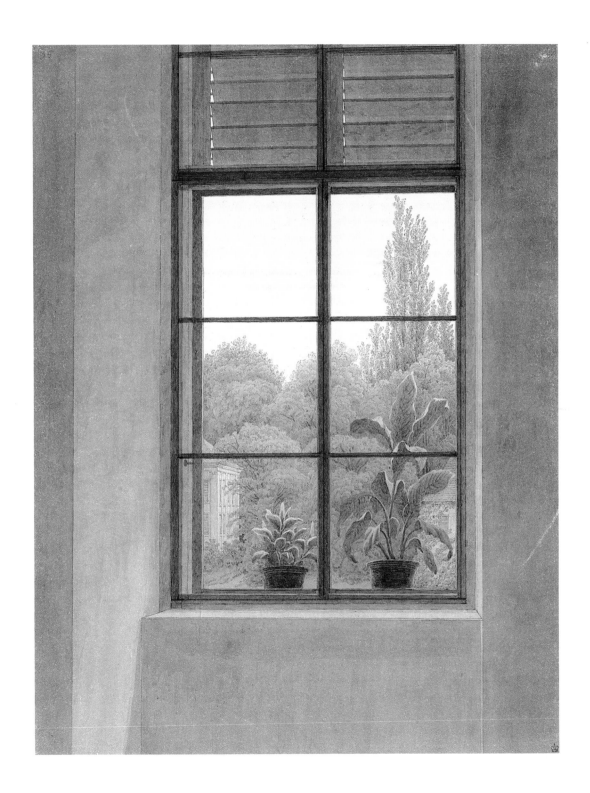

43

the window was opened (such windows open inward). Indeed, in a famous painting by Friedrich's friend Georg Friedrich Kersting (1785–1847) titled *Woman Embroidering*, 1812 (first of three versions, Kunstsammlungen zu Weimar), a row of potted plants rests comfortably on a sill outside an open window.

The location depicted remains a puzzle. After visiting the artist in 1810, Johanna Schopenhauer (1766–1838), mother of the philosopher Arthur Schopenhauer, described a group of now-lost sepia drawings that presumably presented views from Friedrich's apartments in Dresden and nearby Loschwitz, where Friedrich had kept a modest summer place since 1801. It has been variously suggested (though tentatively, since Schopenhauer mentioned "small" works) that the present drawing might have been part of this group. The window here is exceptionally high, containing ten glass panes, with the top two cut off by the picture's upper edge. It does not match those in Friedrich's Dresden apartment or those in the one where he lived after 1820, nor would it match those in the Loschwitz apartment, which he once described as belonging to a farmhouse complete with chickens, pigeons, and a chained dog.[1]

Opinions differ concerning the date of this work. The artist's cataloguer, Helmut Börsch-Supan, relates the picture's meticulous style to the artist's precise studies from nature of 1806–11, thus proposing the same date.[2] It has also been suggested that this work dates from 1835–37, since all of the other sepia drawings Friedrich sent to Russia date from that later period. This theory is given further weight by the fact that Friedrich again painted window views after his stroke in 1835. One such view, now lost, was purchased by the Saxon Art Association in October 1837.[3]

Friedrich's friend the painter Gerhard von Kügelgen (1772–1820) rented a fine property, the Weinberg in Loschwitz, for a summer or two about 1810.[4] Less than ten years later, he bought the Weinberg, but while he was still redecorating it, he was murdered when traveling to Loschwitz by a soldier turned highwayman. Kügelgen's widow kept the house until about 1830. Friedrich may have composed this view from one of the windows at the Weinberg about 1810 or after Kügelgen's death, in memory of his friend.

Like Friedrich's other sepia drawings now at the Hermitage and Pushkin museums, this one was probably purchased by the Russian poet Vasily Andreyevich Zhukovsky (1783–1852) for the imperial family. It entered the Hermitage after 1917.

1. Hoch 1985, p. 23.
2. Borsch-Supan and Jähnig 1973, no. 174, p. 306.
3. Sumowski 1970, p. 147.
4. Wilhelm von Kügelgen, *Jugenderinnerungen eines alten Mannes*, ed. and with a foreword by Adolf Stern (Leipzig, 1903), p. 583.

EXHIBITIONS
1974 Leningrad, no. 11; 1974 Hamburg, no. 223; 1974–75 Dresden, no. 173; 1976–77 Paris, no. 56; 1978 Tokyo–Kyoto, no. 43; 1985 Moscow (unnumbered); 1987 Sapporo, no. 63

LITERATURE
Isergina 1964, pp. 31, 33 (ill.); Hinz 1966, p. 73; Sumowski 1970, pp. 79, 147 note 817, 196, 233, 237, fig. no. 319; Börsch-Supan and Jähnig 1973, no. 174; Bernhard and Hofstätter 1974, p. 383; de Paz 1986, p. 174 (pl. 64)

Ruin of Wolgast Castle
Burgruine von Wolgast

1813
Pen and ink; 5⅛ x 5¼ in. (13.1 x
14.4 cm). Inscribed, in black ink:
*Das Schloss zu Wolgast in Schwedisch
Pommern. Dresden im Dec. 1813.* The
cardboard mount is inscribed, by a
different hand, in ink: *Friedrich*; in
pencil: *(1813)*
Pushkin State Museum of Fine Arts,
Moscow. Inv. no. 13423

In 1813 troops of Napoleon's Grande Armée entered Dresden, and
the staunchly patriotic Friedrich moved to the Elbsandsteingebirge,
a mountainous region southeast of Dresden, to wait out the occu-
pation. For the artist, this was a time of grave financial and emo-
tional hardship. He seems to have worked little, because only a handful
of works, mostly on paper, survive from 1813.

This ink drawing may have been part of a planned but unreal-
ized series of topographical views of historic monuments.[1] Since
Friedrich did not travel to Wolgast in 1813, he probably based the
drawing on an existing earlier study from nature. The image repre-
sents the forty-five-foot donjon tower of the ruined fourteenth-
century ducal castle of Wolgast, as if seen and drawn from a boat
moored at a distance from the shore. The dramatic ruin is set side
by side with peasants' huts (which may or may not have actually
existed)—a particular juxtaposition that Friedrich enjoyed and often
depicted in his work. The town of Wolgast lies on a narrow sound
on the Baltic coast less than twenty miles east of Friedrich's birth-
place, Greifswald. In 1813, the date of this drawing, Wolgast still
belonged to Sweden. Only two years later, it became part of Prussia.

Friedrich's drawing may be the only surviving record of this
ruin; some thirty-five years later, it was razed.[2]

1. Börsch-Supan and Jähnig 1973, no.
 210, p. 329.
2. E. von Haselberg, *Die Baudenkmäler des
 Regierungs-Bezirks Stralsund*, Gesell-
 schaft für Pommersche Geschichte
 und Alterthumskunde (Stettin, 1881),
 pp. 173–82.

EXHIBITIONS
1970 Leningrad, no. 61; 1974 Leningrad,
no. 12; 1974–75 Dresden, no. 182; 1985
Leningrad–Moscow, cat. p. 31

LITERATURE
Börsch-Supan and Jähnig 1973, p. 29,
no. 210; Bernhard and Hofstätter 1974,
p. 590

Das Schloß zu Wolgast, in Schwedisch-Pommern. Dresden im Dec 1813.

On the Sailboat
Auf dem Segler

1818–19
Oil on canvas; 28 x 22 in. (71 x 56 cm)
State Hermitage Museum,
Leningrad. Inv. no. GE 9773.
Acquired in 1945

The forty-four-year-old Friedrich, seemingly a confirmed bachelor, married in January 1818. His friends were astounded. The following summer, Friedrich took his bride, Caroline, to Greifswald to present her to his family. From there, Friedrich and his brother Christian, together with their wives, continued along the Baltic coast, visiting Wolgast, Stralsund, and the island of Rügen. Upon returning to Dresden, Friedrich evoked the voyage in this painting, and possibly also in *Sisters on the Harbor-View Terrace (Harbor by Night)*, ca. 1820 (p. 52), and *Moonrise by the Sea*, 1821 (p. 56).

The couple holding hands in the bow of the boat thus might be seen as a double portrait of the artist with his wife, Caroline (though not a literal one, since Friedrich did not have long hair). The seascape probably represents the three-mile-wide Greifswalder Bodden between the island of Rügen and Greifswald, here a poetic amalgam of the spires and buildings of Dresden, Greifswald, and Stralsund. Friedrich reduced the size of the figures purposely, thereby enlarging the wooden mast and the wind-filled sails dramatically. He had previously shown the boat in normal scale in a study from

Fig. 34 Caspar David Friedrich, *Drawing for "On the Sailboat,"* ca. 1818. Pencil and wash, 14⅛ x 10¼ in. (36 x 26 cm). Nasjonalgalleriet, Oslo.

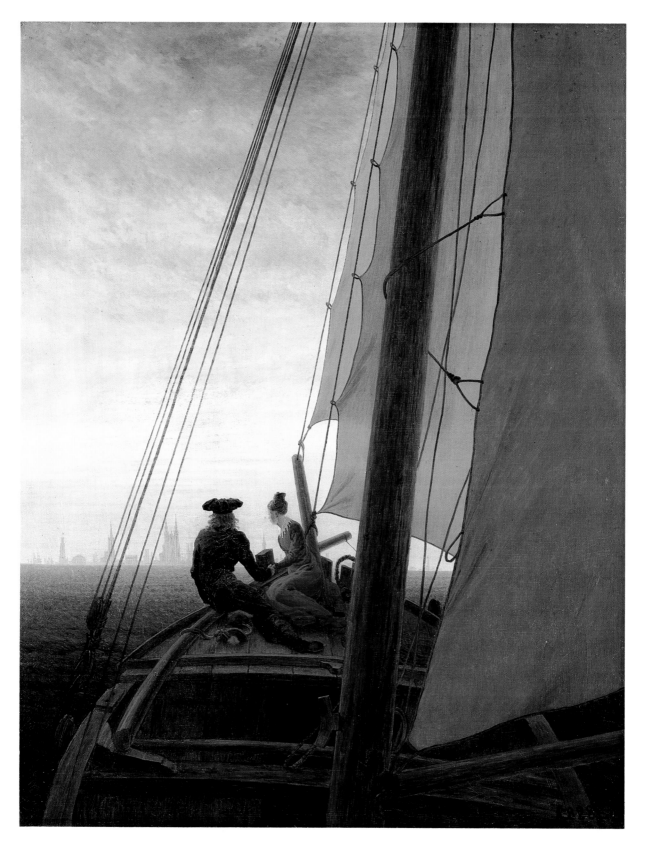

nature (Fig. 34). Friedrich's innovative cropping of the composition's top, sides, and foreground creates in the viewer the sensation of being on shipboard and feeling the up-and-down motion of the waves.

The implicit Romanticism of the painting has been widely interpreted. The image has been seen as an allegory of the evening of the artist's life—and the distant harbor as "the beyond"—or as the dawn of the couple's new life together. Whatever else the picture's meaning may be, it certainly appealed to another recently married couple, Grand Duke Nikolai Pavlovich (1796–1855; the future Czar Nicholas I of Russia, r. 1825–55) and his wife Alexandra Fedorovna (the former Prussian princess Charlotte Louise). During their first trip to Germany together in 1820—they married in 1817—they visited Friedrich in Dresden and purchased this work right out of his studio. They hung the painting in the English cottage, which Nicholas I built in 1829 as his summer residence in the Alexandria Park at Peterhof. In 1945 the work was acquired by the Hermitage.

EXHIBITIONS
1964 Heidelberg, no. 173; 1965 Berlin, no. 62; 1974 Leningrad, no. 1; 1974 Hamburg, no. 139; 1974–75 Dresden, no. 26; 1976–77 Paris, no. 66; 1978 Tokyo-Kyoto, no. 12; 1980 Oslo, no. 155; 1981 Stockholm, no. 74; 1985 Moscow (unnumbered); 1985 Munich, no. 100; 1987 Hamburg (unnumbered), pp. 32–33; 1990 Essen, no. 13

LITERATURE
Isergina 1956, pp. 255, 265, 266, 275; Hermitage catalogue 1958, vol. 2, p. 358; Börsch-Supan 1960, p. 96; Eimer 1960, pp. 230–41; Eimer 1963, p. 24; Prause 1963, p. 33; Emmrich 1964, p. 104 (pl. 19); Hinz 1964, p. 245; Geismeier 1965, p. 12; Hinz 1966, p. 71 note 1; Prause 1968, p. 27; Börsch-Supan 1969, p. 401; Sumowski 1970, pp. 84, 204, 207, 219, 234; Börsch-Supan 1972, p. 629; Börsch-Supan and Jähnig 1973, no. 256, p. 32; Geismeier 1973, p. 42, pl. 48; Börsch-Supan 1974, p. 43; Eimer 1974, p. 146; Schmied 1975, fig. 25; Börsch-Supan 1976, no. 88; Kostenevich 1976, nos. 22, 23; 1976–77 Paris, p. 59; Linnik 1977, no. 113; Jensen 1978, p. 164; Rautmann 1979, pp. 87, 88; Walther 1983, no. 10; Unverfehrt 1984, p. 123, pl. 95; Nikulin and Asvarishch 1986, nos. 244, 245; Kostenevich 1987, no. 18; Asvarishch 1988, no. 51; Hofmann 1988, pp. 67–74

Detail: *On the Sailboat*

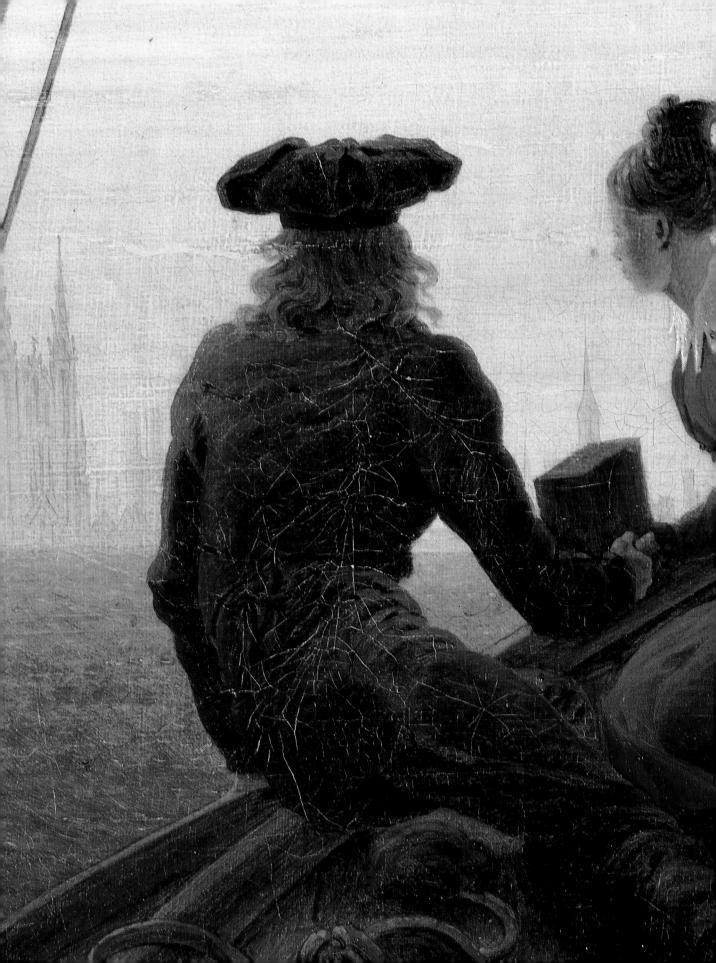

Sisters on the Harbor-View Terrace (Harbor by Night)
Die Schwestern auf dem Söller am Hafen (Nächtlicher Hafen)

ca. 1820
Oil on canvas; 29⅛ x 20½ in. (74 x 52 cm)
State Hermitage Museum, Leningrad. Inv. no. GE 9774.
Acquired in 1945

Friedrich's visit to Greifswald with his wife, Caroline, in the summer of 1818, a few months after their marriage, might have been an inspiration for this painting. Writing to his brother Heinrich in Greifswald in March 1818, Friedrich described his young wife's eager anticipation of meeting her husband's family and her excitement about traveling—something she seems to have never done before.[1]

The two young women standing on a terrace or bridge might be Friedrich's wife, Caroline, and his brother Christian's wife (see p. 48). At night and in fog, they face a harbor whose buildings derive from four different cities: Halle, Stralsund, Neubrandenburg, and Greifswald. A memorial for those drowned at sea with cross and two mourning figures appears on the right, behind the balustrade that, not unlike a stage prop, neatly divides the composition into foreground and background.

Pensive foreground figures were among Friedrich's favorite motifs. Usually seen from the back, they serve as allegories for Roman-

Fig. 35 Caspar David Friedrich, *Two Women on a Balcony*, ca. 1818. Pen and brush, 10¹/₁₆ x 8¹³/₁₆ in. (25.6 x 22.4 cm). Nationalgalerie, Sammlung der Zeichnungen, Staatliche Museen zu Berlin.

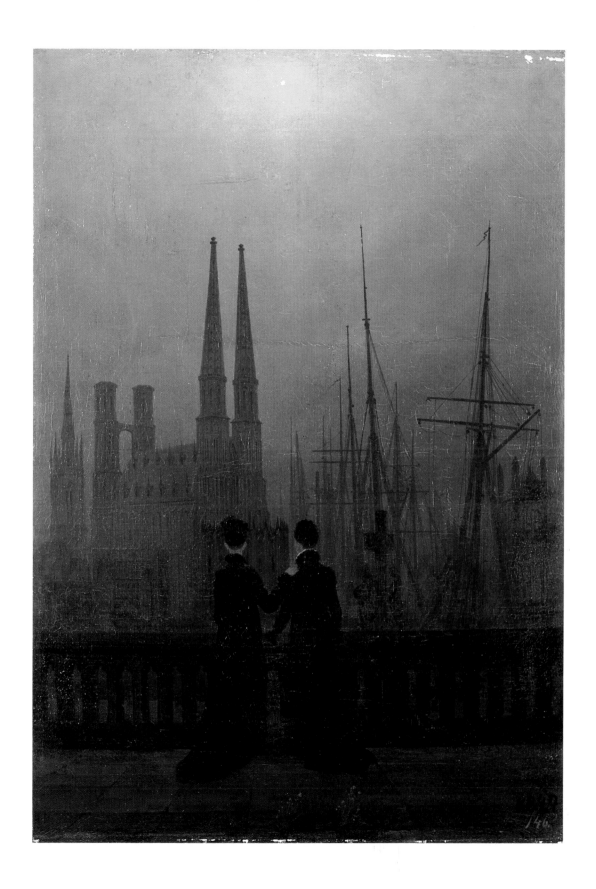

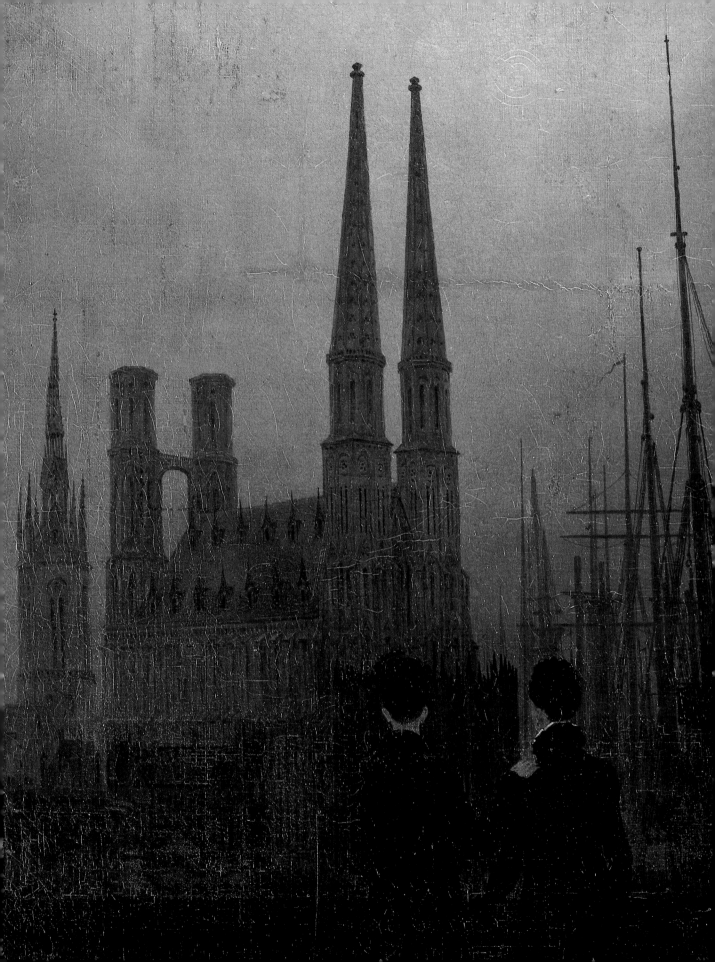

tic yearning. By placing them in or near the center of his pictures, Friedrich makes the viewer identify with their angle of vision and thus share their contemplation. In Friedrich's works, these figures —alone or in pairs and lost in reverie, often before a rising moon or sinking sun—are usually men. The pairing of two women alone is as unique as is the urban setting, though probably tied to it. Only men roam Friedrich's open landscapes. The cityscape is entirely composed of Gothic architecture and the rigging and wooden masts of sailing boats, with all of these elements echoing each other. By placing a Gothic church in a harbor of tall ships, Friedrich suggests that both are metaphors for refuge and protection. The piety of the scene is matched by the women's medieval silhouettes, so erect and severe in their high-necked, long-sleeved, long-trained formal Old German gowns.

When the Russian grand duke Nikolai Pavlovich visited Friedrich's studio in Dresden in December 1820, he bought this painting, along with *On the Sailboat*, 1818–19 (p. 48). Both pictures hung in the English cottage, Nicholas I's summer residence at Peterhof, until 1945, when they were acquired by the Hermitage.

1. Hinz 1968, p. 35.

EXHIBITIONS
1820 Dresden, no. 547; 1965 Berlin, no. 60; 1974 Leningrad, no. 2; 1974 Hamburg, no. 143; 1974–75 Dresden, no. 28; 1976–77 Paris, no. 67; 1978 Tokyo-Kyoto, no. 15; 1980 Oslo, no. 15; 1981 Stockholm, no. 156; 1985 Moscow (unnumbered)

LITERATURE
Böttiger 1820, no. 41; Kunstblatt 1820, p. 380; Wiener Zeitschrift 1820, p. 990; Literarisches Conversationsblatt 1821, p. 39; Sigismund 1943, pp. 68, 107 note 13, 121; Feist 1956, pp. 449–52; Isergina 1956, pp. 264, 265; Börsch-Supan 1960, p. 50; Eimer 1960, p. 238; Eimer 1963, p. 17; Emmrich 1964, pp. 29, 37, 118, 119 (pl. 43); Hinz 1964, p. 265 note 5; Geismeier 1965, pp. 54, 55; Hinz 1966, p. 71 note 1; Sumowski 1966, pp. 40–41; Hinz 1968, ill. between pp. 176 and 177; Sumowski 1970, pp. 86, 109, 124, 131, 200, 205, 234; Börsch-Supan and Jähnig 1973, no. 263, p. 28; Geismeier 1973, p. 43, pl. 42; Eimer 1974, p. 139; Märker 1974, pp. 97–101; Schmied 1975, fig. 24, p. 36; Börsch-Supan 1976, no. 95; Rautmann 1979, pp. 86–91, 170 note 28; Unverfehrt 1984, fig. 56, pp. 66, 76, 123; Nikulin and Asvarishch 1986, no. 252; Kostenevich 1987, no. 20; Asvarishch 1988, no. 52

Detail: *Sisters on the Harbor-View Terrace (Harbor by Night)*

Moonrise by the Sea
Mondaufgang am Meer

1821
Oil on canvas; 53⅛ x 66⅞ in. (135 x
170 cm)
State Hermitage Museum,
Leningrad. Inv. no. GE 6369.
Acquired in 1928

Friedrich never left Germany in search of exotic motifs. In his na-tive country, he also avoided conventionally beautiful sites. He drew his motifs mainly from two regions: the mountains of the Elbsand-steingebirge, the Riesengebirge, and Bohemia, all southeast of Dres-den; and his native northern Baltic coast and the island of Rügen. While visiting these places, he drew precise studies from nature —clouds, rocks, plants, trees, boats, ruins—which constituted for him a permanent "motif-stock" from which he composed his water-colors and paintings. He would often use certain motifs more than once, and in different combinations. He never painted from nature.

It has been pointed out that Friedrich's relatively empty land-scapes fall into two main categories. Either they serve as settings for objects of contemplation, such as ruins, churches, trees, crosses, or sailing ships; or they are views toward an infinity where light itself is the object to be contemplated.[1] Friedrich shunned the light of day, and only light as seen by night, at dusk or at dawn, at sunrise or at sunset, in fog or in mist, was depicted in his works.

The site shown is probably the beach of Stubbenkammer, on the northeast coast of the island of Rügen, which Friedrich, his brother Christian, and their wives had visited in the summer of 1818. This austere island, which according to some visitors offered little to the eye but much to the mind,[2] had been Friedrich's favorite haunt since 1798–99. Fishermen would fear for the artist's life while watching him roam over the high chalk cliffs in a high wind.[3] The artist's painted seascapes always show calm waters, however, as in this scene in which a full moon illuminates an immense sky and the beach already lies in darkness. Two tiny sailboats appear barely visi-ble near the distant horizon. While two women watch from a large boulder in the foreground, their two male companions stand far-ther out on a rock in the water. Two large rusty anchors stand aban-doned in the left foreground. Since Friedrich deliberately paired figures and objects here, it may be no accident that the sailing ships are visually connected with the men and the anchors with the women.

The Russian poet Vasily Andreyevich Zhukovsky vividly de-scribed this picture in his letter of June 23, 1821 (see p. 22) to Alex-andra Fedorovna, the wife of Grand Duke Nikolai Pavlovich. He had seen the painting in Friedrich's studio in Dresden and suggested

Detail: *Moonrise by the Sea*

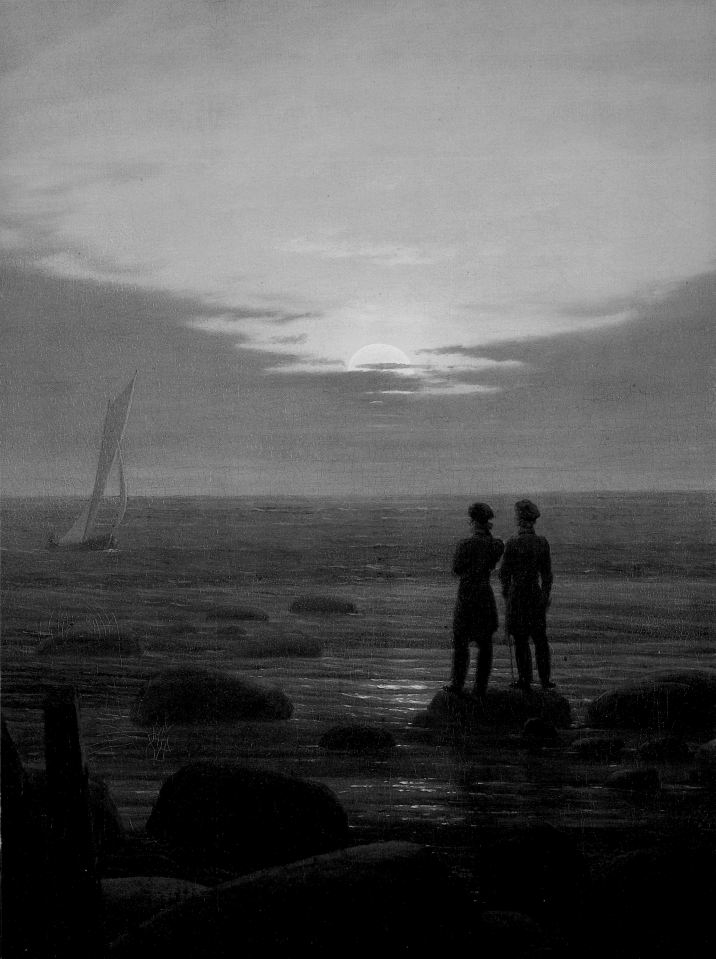

its acquisition, which followed. The work then hung in Alexandra Fedorovna's rooms in the palace at Ropsha, near Saint Petersburg, with another landscape by Friedrich, *Landscape in the Riesengebirge*, 1810 (Pushkin State Museum of Fine Arts, Moscow).

1. Siegmar Holsten, "Friedrichs Bild-themen und die Tradition," in *Caspar David Friedrich 1774–1840*, Kunst um 1800, exh. cat. (Hamburg: Hamburger Kunsthalle, 1974), p. 44.
2. Sumowski 1970, p. 25.
3. Hinz 1968, p. 230.

EXHIBITIONS
1821 Dresden (not in catalogue); 1824 Prague, no. 198; 1958 Stralsund, no. 30; 1965 Berlin, no. 63; 1974 Leningrad, no. 5; 1974 Hamburg, no. 156; 1974–75 Dresden, no. 34; 1978 Tokyo–Kyoto, no. 17; 1989 Vienna (unnumbered), p. 113

LITERATURE
Gesellschafter 1821, p. 773; Wiener Zeitschrift 1821, p. 997; Böttiger 1822, p. 5; Archiv für Geschichte 1824, p. 377; Böttiger 1824, p. 18; Gesellschafter 1824, p. 352; Kunstblatt 1824, p. 208; Merkur 1824, p. 239; Wiener Zeitschrift 1824, p. 780; Einem 1939, p. 172; Isergina 1956, p. 263; Börsch-Supan 1960, p. 98; Heider 1963, pp. 373, 374; Emmrich 1964, pp. 37, 66, 93, 94, 95 (pl. 20); Hinz 1964, p. 266 note 5; Masaryková 1964, p. 99; Hinz 1966, p. 71 note 1; Hinz 1968, ill. between pp. 176 and 177; Sumowski 1970, pp. 70, 75, 84, 115, 155, 206, 214, 220, 227, 234; Börsch-Supan and Jähnig 1973, no. 281, p. 36; Geismeier 1973, p. 67; Börsch-Supan 1976, no. 114; Kostenevich 1976, no. 24; Linnik 1977, no. 112; Unverfehrt 1984, fig. 57, p. 123; Nikulin and Asvarishch 1986, nos. 250, 251; Kostenevich 1987, nos. 21, 22; Asvarishch 1988, no. 53

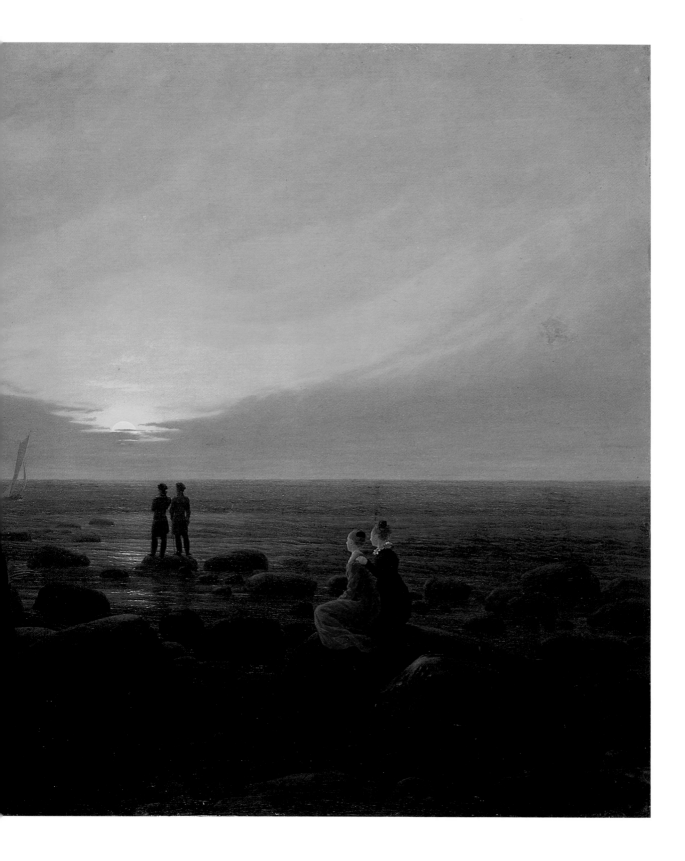

Morning in the Mountains
Der Morgen im Gebirge

1822–23
Oil on canvas; 53⅛ x 66⅞ in. (135 x 170 cm)
State Hermitage Museum, Leningrad. Inv. no. GE 9772.
Acquired in 1945

In July 1810, Friedrich and his friend the painter Georg Friedrich Kersting set off on foot to explore the Riesengebirge, the high mountains between Silesia and Bohemia, southeast of Dresden. The walking tour became a rich source of inspiration, and it supplied Friedrich with motifs for paintings and watercolors until the end of his life. Friedrich's sketchbook is now dispersed and some sheets are lost, but his dated sketches provide a precise itinerary of the trip.[1] The two friends must have left Dresden on foot sometime late in June 1810, because by July 4 they had arrived at the monastery on the Oybin mountain near Zittau, some thirty miles southeast of Dresden. On July 10, they came to the source of the river Elbe, about fifteen miles farther. On July 11, they climbed the peak of the Schneekoppe (5,293 feet), the highest mountain of the Riesengebirge. On July 12, they started their descent and returned via a different route.

During one of various walks Friedrich made from the summit of the Schneekoppe on July 11—as he descended toward the Wiesenbaude mountain, moving along the ridge of the Koppenplan—he saw the view shown here.[2] It faces west, the direction from which he had come, toward the curving ridge of the Ziegenrücken and the twin peak of the Jeschken in the far distance.

This painting is based on a now-lost drawing Friedrich executed during the walk between the Schneekoppe and the Wiesenbaude on July 11. Also based on this lost drawing are the painting *Riesengebirge*, ca. 1830–35 (Nationalgalerie, Staatliche Museen Preussischer Kulturbesitz, Berlin), and a later sepia drawing of 1839–40 (BS 513).[3] Both show the same view. Only in this work, however, which Friedrich exhibited as *A Mountain Region (Personal Arrangement)*, did he include such dramatic foreground elements as the chasm between the two pointed rocks and the slope rising on the right.

Barely visible are the tiny shepherd and his muse high up on the rock at the left. They guard five sheep and three goats, also just visible, that graze on the green slope to the right. Friedrich did not care for strong daylight. He thus chose to depict an early morning, whose overcast light has tinted the distant mountains hazy pink, beige, mauve, and rust. Further softening the atmosphere is the early-morning mist rising in the valleys.

Detail: *Morning in the Mountains*

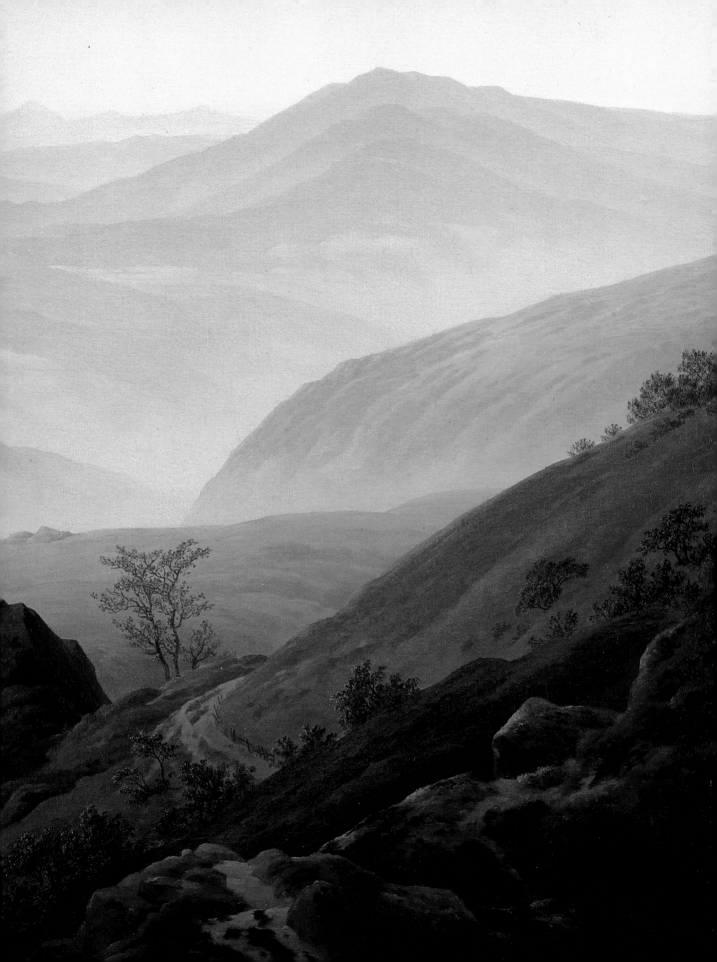

Because this work has the same dimensions as *Moonrise by the Sea*, 1821 (p. 56), and represents the hour before sunrise, the paintings, which are Friedrich's largest surviving works, have been seen as pendants. However, this picture was not hung together with the other work in the palace at Ropsha but was exhibited in the first-floor drawing room of the English cottage at Peterhof. It entered the collection of the Hermitage in 1945.

1. Günther Grundmann (1965) established the precise itinerary of Friedrich's trip with the help of the artist's dated sketches. See his chapter "Caspar David Friedrich, der Romantische Maler des Riesengebirges," pp. 68–99, and addendum, pp. III–IX.
2. See Schmied 1975, p. 112.
3. BS numbers refer to Börsch-Supan and Jähnig 1973.

EXHIBITIONS
1823 Dresden, no. 606; 1974 Leningrad, no. 6; 1974 Hamburg, no. 165; 1974–75 Dresden, no. 40

LITERATURE
Böttiger 1823, p. 64; Gesellschafter 1823, p. 683; Licio 1823, p. 610; Literarisches Conversationsblatt 1823, p. 965; Wiener Zeitschrift 1823, p. 1070; Einem 1939, p. 184; Isergina 1956a, pp. 264, 265 (ill.), 276; Hermitage catalogue 1958, vol. 2, p. 358; Emmrich 1964, pp. 83, 85 (pl. II); Grundmann 1965, pp. VII–IX; Hinz 1966, p. 80; Börsch-Supan 1967, p. 149; Hinz 1968, ill. between pp. 176 and 177; Sumowski 1970, pp. 78, 80, 206, 234; Börsch-Supan and Jähnig 1973, no. 300, p. 36; Börsch-Supan 1976, no. 133; Walther 1983, p. 13 (ill.); Nikulin and Asvarishch 1986, nos. 247–49; Asvarishch 1988, no. 54

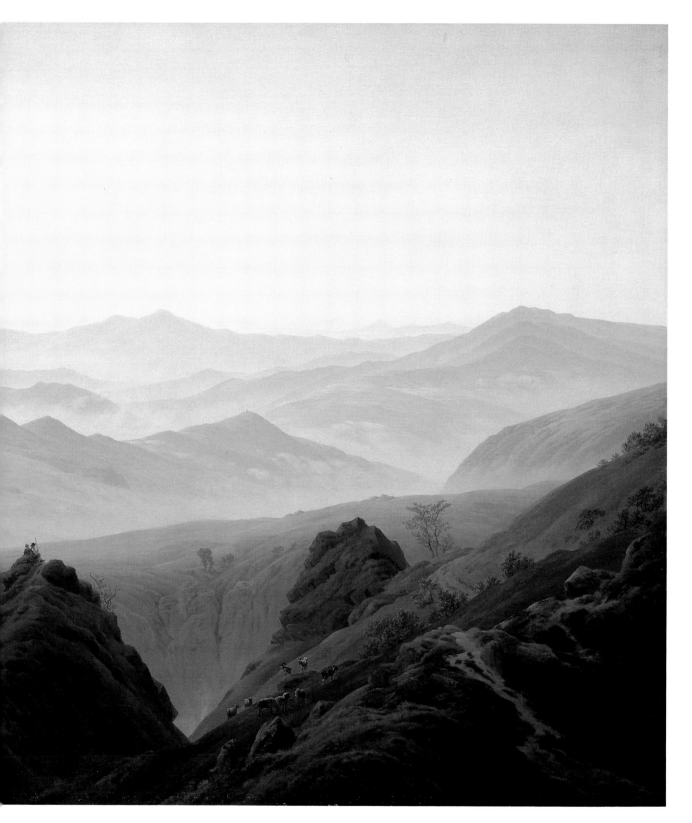

Ruins of Eldena Monastery
Die Ruine des Klosters Eldena

ca. 1824–26
Pencil and watercolor; 17¹³⁄₁₆ x 13½ in.
(19.8 x 34.4 cm)
Pushkin State Museum of Fine Arts,
Moscow. Inv. no. 4251. Acquired
in 1930

Friedrich was so fascinated by the ruins of the Gothic church and monastery in the Baltic town of Eldena that he depicted them, at different times in his career, by night, day, dusk, and moonlight, and in ink, watercolor, sepia, and oil. Surrounded by large grounds on the southern shore of the Greifswalder Bodden in the Baltic Sea, some three miles east of Greifswald, the Eldena church and monastery were built between 1200 and 1400. They were damaged by Sweddish troops in the mid-seventeenth century and then used as a quarry until the mid-eighteenth century. Since that time—down through Friedrich's day and ours—the ruins have remained unchanged.

Friedrich most often represented the ruins' most dramatic view—the high west wall pierced by a window, as seen from the

Fig. 36 The approximate view depicted in *Ruins of Eldena Monastery*.
Photograph, late 1960s.

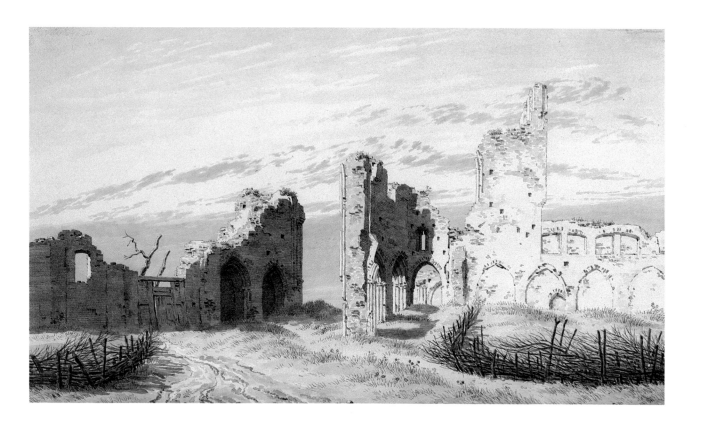

Fig. 37 Caspar David Friedrich, *Ruins of Eldena Monastery*, 1801. Pen and brown ink, brown-gray wash and pencil, 6⅞ x 13⅛ in. (17.5 x 33.3 cm). Staatsgalerie Stuttgart, Graphische Sammlung.

Fig. 38 Caspar David Friedrich, *Ruins of Eldena Monastery, As Seen from the Northeast*, ca. 1806. Watercolor, wash, and pencil, 7 x 9 in. (17.8 x 22.9 cm). Sammlung Georg Schäfer, Schweinfurt.

Fig. 39 West façade of the Eldena monastery ruins. Photograph, late 1960s.

northeast (Fig. 38). He thought nothing of changing the ruins' structure by adding or deleting elements, of opening a window in the high west wall that was in reality closed over, or even of transplanting Eldena from the shore to a slope, a hill, or the mountains of the Riesengebirge some two hundred thirty miles farther southeast.

This particular watercolor shows the least dramatic view—the eastern portion of the ruins, as seen from the southwest. Friedrich copied the image, at the same size, from an earlier drawing that he had done from nature in 1801 (Fig. 37).[1] The only other two versions of this view—which are also based on the 1801 drawing—are a night scene of about 1803 (formerly private collection, Würzburg; destroyed in 1944) and a watercolor of 1814 showing only the right side of the ruins (Kupferstichkabinett, Staatliche Kunstsammlungen Dresden).

By the late 1820s, the grounds of Eldena were cleared of rubble, made accessible, and planted,[2] as is documented in this unusually picturesque view of the ruins complete with sunshine, green grass, and a wattle fence.

1. Börsch-Supan and Jähnig 1973, no. 327, p. 395.
2. E. von Haselberg, *Die Baudenkmäler des Regierungs-Bezirks Stralsund*, Gesellschaft für Pommersche Geschichte und Alterthumskunde (Stettin, 1881), pp. 70–72.

EXHIBITIONS
1963 Moscow, cat. p. 81; 1974 Leningrad, no. 14; 1974–75 Dresden, no. 207; 1975 Moscow–Leningrad, no. 3; 1984 Paris, no. 368; 1985 Leningrad–Moscow, cat. p. 31

LITERATURE
Liebmann 1957a, pp. 143, 144; Liebmann 1957b, p. 533 (ill.); Hinz 1966, p. 58, no. 262; Sumowski 1970, p. 163, fig. no. 363; Börsch-Supan and Jähnig 1973, no. 327, p. 37; Geismeier 1973, ill. 12; Bernhard and Hofstätter 1974, p. 254

Ruin on the Schlossberg
Ruine auf dem Schlossberg

1828
Pencil and watercolor; 7⅞ x 8½ in.
(18.8 x 21.5 cm). Watermark:
J. Whatman Turkey Mill 1818
Pushkin State Museum of Fine Arts,
Moscow. Inv. no. 4250. Acquired
in 1930

In early May of 1828, Friedrich spent several days at Teplitz, a spa south of Dresden in Bohemia. Friedrich traveled with the Russian engraver August Clara (b. 1790), who had been sent to him by his Russian friend and patron, the poet Vasily Andreyevich Zhukovsky. They stayed at the Töpferschenke, an inn that Goethe and Ludwig Tieck had also visited. According to the inn's guest book, Friedrich and Clara had arrived on foot from Dresden, some thirty-five miles distant. They listed the purpose of their visit as "art trip."[1]

On the day of his arrival—May 9, 1828—Friedrich executed a pencil drawing (Kupferstichkabinett, Staatliche Kunstsammlungen Dresden) of one part of the ruined castle atop the Schlossberg, the hill outside the spa. As was his practice so often, Friedrich used this study from nature for a later watercolor, the one shown here.[2] A pendant, showing a different part of the same ruin surrounded by two trees, with a tiny figure of Clara sketching next to it, is also in the collection of the Pushkin Museum (BS 378). Like the earlier watercolor of Eldena (see p. 64), these topographical, sunny views of ruins—more picturesque than dramatic—belonged to a genre much cultivated at the time.

Friedrich returned to Teplitz seven years later, during the months of August and September 1835, to recuperate from his stroke.

Fig. 40 Ruin on the Schlossberg, near Teplitz.
Photograph taken at the turn of the century.

1. Hoch 1985, pp. 113–16.
2. Hoch (1985, p. 114) changed the title of this work, until now cited in the literature as *Schlossruine Teplitz* (*Castle Ruin, Teplitz*), to the more correct *Ruine auf dem Schlossberg* (*Ruin on the Schlossberg*).

EXHIBITIONS
1974 Leningrad, no. 17; 1974–75 Dresden, no. 221; 1975 Moscow–Leningrad, no. 2; 1985 Leningrad–Moscow, cat. p. 31

LITERATURE
Liebmann 1957a, p. 144 (ill.), 146; Liebmann 1957b, p. 533; Hinz 1966, no. 741; Sumowski 1970, pp. 129, 162, 163, 164, 240, fig. no. 357; Börsch-Supan and Jähnig 1973, no. 377; Bernhard and Hofstätter 1974, p. 749; Hoch 1987, fig. 47, pp. 22, 108, 109, 112

The Nets
Die Netze

ca. 1830–35
Oil on canvas; 8½ x 11¾ in. (21.5 x 30 cm)
State Hermitage Museum, Leningrad. Inv. no. 6480.
Acquired in 1928

After visiting the artist's studio in 1810, Johanna Schopenhauer wrote to a friend: "The works of Friedrich differ greatly from those of other landscape painters in their motifs. The air—even though he paints it masterfully—takes up more than half of the space in most of his compositions. Middle- and background are often missing because his motifs don't require them. He likes to paint unfathomable plains. He is faithful to nature even in the smallest details, and he has mastered his technique—in his oil paintings and sepia drawings—to perfection. His landscapes contain a melancholy, mysteriously religious meaning. They affect the heart more than the eye."[1]

For less perceptive viewers at the time, this small work contained startlingly little. Birds fly toward a full moon partly hidden by clouds. Its light, reflected in puddles in the foreground and on the distant sea, barely illuminates the nets spread on poles to dry. So simple and serene is the scene that Friedrich did not even bother to add one of his wanderers to take in the view.

1. Johanna Schopenhauer, "Über Gerhard von Kügelgen und Friedrich in Dresden. Zwei Briefe, mitgeteilt von einer Kunstfreundin," 1810, cited in Börsch-Supan and Jähnig 1973, p. 78. Translation here by Sabine Rewald.

EXHIBITIONS
1958 Stralsund, no. 31; 1974 Leningrad, no. 8; 1974 Hamburg, no. 206; 1974–75 Dresden, no. 60

LITERATURE
Isergina 1956a, pp. 264, 276; Hermitage catalogue 1958, vol. 2, p. 358; Börsch-Supan 1960, p. 42; Hinz 1966, p. 105; Sumowski 1970, pp. 123, 124, fig. no. 266; Börsch-Supan and Jähnig 1973, no. 397; Börsch-Supan 1976, no. 199; Asvarishch 1988, no. 56

Swans in the Reeds by Dawn's Early Light
Schwäne im Schilf beim ersten Morgenrot

ca. 1832
Oil on canvas; 13⅜ x 17⅜ in. (34 x 44 cm)
State Hermitage Museum, Leningrad. Inv. no. 4633.
Acquired in 1928

Although Friedrich rarely depicted quadrupeds, he often painted birds, such as swans, owls, and crows. Swans only live in pairs, and if the mate dies, the survivor remains solitary. These regal birds have long been romanticized. The swan appears as a cult bird in Celtic mythology. It is a deity in old Irish legends, and no less a Romantic than Richard Wagner gave it a feature role in his opera *Lohengrin* (1847). The bird's elegant shape and sinuous neck also appealed to the French *ébénistes* of the Directory and Empire periods (ca. 1795–ca. 1815), who decorated furniture and objects with swan motifs.

The exceptionally decorative motif of two swans in reeds appears at least five times in Friedrich's oeuvre. The earliest example, showing the birds by moonlight, dates from 1821 (Freies Deutsches Hochstift, Frankfurt am Main). The now-lost picture of a single swan—*Hermit-Swan*, ca. 1822—was evoked in a sonnet by the poet Friedrich de la Motte-Fouqué after he saw it in Friedrich's studio in 1822.

Here, the pink of the dawn is echoed in the red of the lotus leaves in the foreground. Börsch-Supan notes the leaves' uniqueness in the artist's oeuvre and points to the poet Otto Heinrich von Loeben's collection of philosophical fragments published under the title *Lotosblätter* (*Lotus Leaves*) in 1817. Loeben, a friend of Fouqué's, had also brought out a collection of poems titled *Der Schwan* (*The Swan*) in 1816.[1]

This small painting might have been part of a shipment of several small works that Friedrich sent to Russia in 1835. The picture hung in the palace at Znamenka, near Peterhof, and was later transferred to the palace at Ropsha and, in 1928, to the Hermitage.

1. Börsch-Supan and Jähnig 1973, no. 400, p. 431.

EXHIBITIONS
1832 Prague; 1974 Leningrad, no. 4; 1974 Hamburg, no. 211; 1974–75 Dresden, no. 61; 1978 Tokyo–Kyoto, no. 26; 1987 Hamburg (unnumbered), pp. 34–35

LITERATURE
Artistisches Notizenblatt 1832, p. 37; Sigismund 1943, pp. 30, 157; Prause 1968, p. 34; Sumowski 1970, p. 227, cat. no. 305; Börsch-Supan and Jähnig 1973, no. 400, p. 41; Börsch-Supan 1976, no. 202; Walther 1983, see no. 26; Asvarishch 1988, no. 55; 1990 London, p. 51 note 17

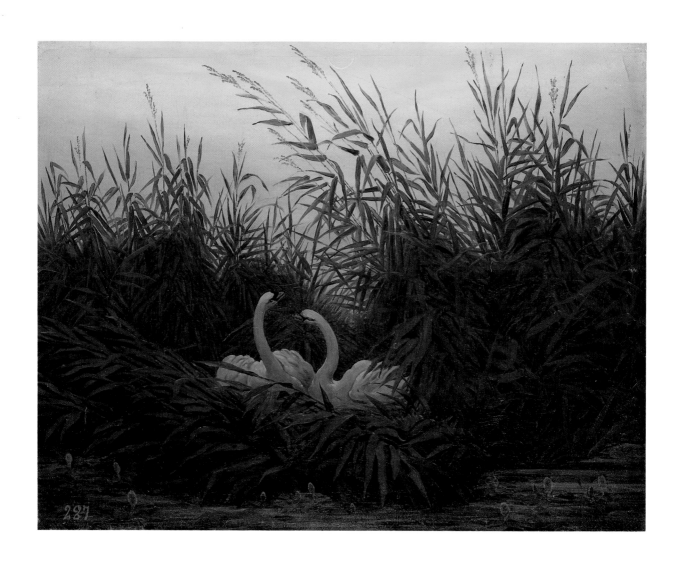

Evening Landscape with Two Men
Abendlandschaft mit zwei Männern

ca. 1830–35
Oil on canvas; 9⅞ x 12¼ in. (25 x
31 cm)
State Hermitage Museum,
Leningrad. Inv. no. GE 1005.
Acquired in 1966

"Do you also find me so monotonous?" Friedrich asked Friedrich de la Motte-Fouqué when the poet visited his studio in 1822. The painter was alluding to criticism that he always used the same motifs in his works. He continued: "People complain that I paint only moonlight, sunsets, sunrises, the sea and coast, snowy landscapes, cemeteries, wild moorlands, forest rivers, rocky coastal valleys, and the like. What do you think?" Fouqué replied, "There is an infinite variety in these motifs when one thinks and paints as you do."[1]

This little painting presents one of Friedrich's favorite motifs. Under a still-red sunset sky, a plain watered by a river leading to a distant sea stretches toward infinity. Two men in capes and berets admire the twilight scene. They are wearing the medieval garb that had been revived by German radical students in the wake of the Napoleonic Wars and the ensuing ultraconservative reaction of Metternich and the Congress of Vienna. Deliberately ignoring the 1819 royal decree that forbade this dress, the staunchly patriotic Friedrich continued to show his figures in this Old German costume until the end of his life.

In traditional landscape paintings, small figures were included as picturesque staffage or as a measure of scale. Here the figures, larger and completely motionless, have become an allegory of yearning and of communion with nature, which the Romantics saw as a manifestation of the spiritual.

Friedrich's rather barren landscapes like this one were surprising at the time. Landscape paintings were supposed to serve as a substitute for travel by showing attractive and interesting scenes that one could enjoy at home. Few would have visited the sites depicted in Friedrich's paintings, except perhaps his fellow Romantic poets and painters. To ordinary viewers, Friedrich seemed to make his landscapes even more inaccessible by immersing them in twilight, fog, or, as here, nightfall. As has been noted, the artist's unusual choice of light was both personal and calculated. He himself disliked bright daylight and is said to have taken walks only early in the morning or late in the evening. At the same time, by enveloping his motifs in veils of obscurity, Friedrich practiced the "alienation effect" recommended by the German Romantic poet Novalis (Friedrich von Hardenberg, 1772–1801) and turned the familiar into the unfamiliar.[2]

The two men here are copied (but reversed) from an earlier ink

Fig. 41 Caspar David Friedrich,
Two Men in Capes, ca. 1815–18. Pen
and ink, 3¹⁵⁄₁₆ x 3¹⁄₁₆ in. (9.9 x 7.8 cm).
Nationalgalerie, Sammlung der
Zeichnungen, Staatliche Museen
zu Berlin.

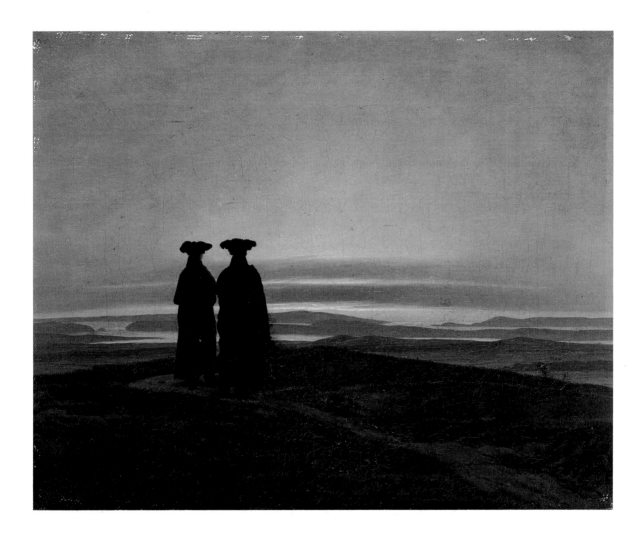

drawing (Fig. 41). Friedrich included the same figures again in his later sepia drawing *Two Men by the Sea at Moonrise*, ca. 1835–37 (p. 90).

Until it entered a private collection in 1917, this small painting hung in one of the imperial residences in Saint Petersburg. The Hermitage acquired it in 1966.

1. Cited in Sumowski 1970, p. 22. Translation here by Sabine Rewald.
2. Novalis, "Logologische Fragmente II," *Das Philosophische Werk I*, in *Schriften*, ed. by Paul Kluckhohn and Richard Samuel, vol. 2 (Stuttgart, 1960–65), p. 545, no. 105 (1798). See also epigraph to this volume.

EXHIBITIONS
1974 Leningrad, no. 9; 1974 Hamburg, no. 212; 1974–75 Dresden, no. 63; 1977 Leningrad, no. 67

LITERATURE
Sumowski 1970, pp. 79, 130, 155, 206, 227, 233, 236, see cat. no. 172, fig. 324; Börsch-Supan and Jähnig 1973, no. 406; Börsch-Supan 1976, no. 208; Asvarishch 1988, no. 58

In Memory of the Riesengebirge
Erinnerung an das Riesengebirge

1835
Oil on canvas; 28⅜ x 40⅛ in. (72 x 102 cm)
State Hermitage Museum, Leningrad. Inv. no. GE 4751.
Acquired in 1925

In memory of his youthful ascent of the Schneekoppe some twenty-five years earlier, Friedrich included its snowy peak in the far distance of this painting, even though it is not actually visible from the location depicted here. Once more the artist has evoked his walking tour of the Riesengebirge with Georg Friedrich Kersting in July 1810. On July 10, the day they arrived at the source of the river Elbe, Friedrich made the drawing (Museum Folkwang, Essen) on which he based this painting.

Behind the source of the Elbe, nestled in the right foreground of the picture, rise three mountains: the Silberkamm on the left, the Ziegenrücken, and the Planuar on the right. The two paintings in the Hermitage collection showing mountains of the Riesengebirge —this work and the earlier *Morning in the Mountains*, 1822–23 (p. 60)—present exactly opposite views. That of *Morning in the Mountains*, as seen from a spot near the peak of the Schneekoppe, looks toward the site shown here, whereas this view looks toward the Schneekoppe.

More textured and grainy than the artist's earlier works, this painting is one of the last that Friedrich executed before his stroke in June 1835. Thereafter, he worked mainly in watercolor and sepia. After the work was exhibited at the Dresden Academy in 1835, it was bought from the artist for 160 thalers by the Saxon Art Association. That year, the association entered it into a lottery in Dresden, and the winning ticket was drawn by the Russian collector P. P. Durnovo. The painting remained in the Durnovo family until 1917.

EXHIBITIONS
1835 Dresden, no. 465; 1974 Leningrad, no. 10; 1974 Hamburg, no. 219; 1974–75 Dresden, no. 65; 1976–77 Paris, no. 82; 1978 Bonn, p. 58; 1985 Munich, no. 98; 1987 Sapporo, no. 45

LITERATURE
Wiener Zeitschrift 1835, p. 1002; Boetticher 1891, no. 23; Sigismund 1943, pp. 38 note b, 89, 114 note 21, 123; Isergina 1956a, pp. 264, 266, 276; Börsch-Supan 1960, pp. 49, 52, 108, 111, 112; Grundmann 1965, pp. VII–IX; Hinz 1966, p. 76; Sumowski 1970, pp. 133, 234; Börsch-Supan and Jähnig 1973, no. 418, p. 33; Börsch-Supan 1976, no. 220; Kostenevich 1976, no. 25; Hoch 1985, pp. 127, 128 (ill.); Nikulin and Asvarishch 1986, no. 246; Hoch 1987, fig. 13; Kostenevich 1987, no. 19; Asvarishch 1988, no. 59

The Dreamer
Der Träumer

ca. 1835
Oil on canvas; 10⅝ x 8¼ in. (27 x 21 cm)
State Hermitage Museum, Leningrad. Inv. no. GE 1360. Acquired in 1918

Friedrich displays his secret love of symmetry by placing the opening of the extremely elongated window exactly in the center of this picture. He also shows his not-so-secret love of Gothic ruins. The one here is the monastery on the Oybin mountain, near the town of Zittau in Saxony. Friedrich and his friend Kersting had visited Oybin on their way to the Riesengebirge in July 1810. The monastery was founded by Emperor Charles IV in the late fourteenth century on the site of a robber's stronghold that he had reduced to rubble. The structure was then destroyed by a fire in the late sixteenth century and by a landslide some hundred years later. The best-preserved part of the monastery was its church with fine Gothic tracery.

The "dreamer" of the picture's title watches a sunset from the window's lower right-hand corner. He is one of the artist's many wanderers—city dwellers, to judge from their dress—who roam his landscapes and worship nature. With one leg dangling and the other resting on the window ledge, he seems more casual than Friedrich's usually frozen figures. Elegant in his fine blue suit and white collar, he evokes—even if he is much smaller—other well-dressed gentlemen pondering nature, such as Goethe in Tischbein's portrait of the German poet in the Roman Campagna of 1786–88 (Goethe-Nationalmuseum, Weimar) and Sir Brooke Boothby in Wright of Derby's painting of 1781 (Tate Gallery, London). The Romantics' wanderers, perhaps personifications of their restless yearning, appear as the ever-traveling heroes of their novels and poems. In music, Franz Schubert (1797–1828) immortalized them in his sonatas and songs, most notably in his *Wanderer* (1821) and *Die Winterreise* (1827).

Friedrich's authorship of this work was at one time subject to doubt. Because his friend the painter and doctor Carl Gustav Carus (1789–1869) had depicted the very same window, but from the outside, in his painting *Cemetery in Winter*, 1828 (Museum der Bildenden Künste, Leipzig), *The Dreamer* was also believed to have been done by Carus. Several studies of fir trees by Friedrich that are directly related to this painting—dated June 30, 1813 (Graphische Sammlung Albertina, Vienna) and July 4, 1813 (Nasjonalgalleriet, Oslo)—reestablished his authorship some thirty years ago. Because of the picture's somewhat patchy brushwork, it is now believed to have been painted after the artist's stroke in June 1835.

Until 1917 the work hung in the rooms of Alexander II in the Anichkov Palace in Saint Petersburg.

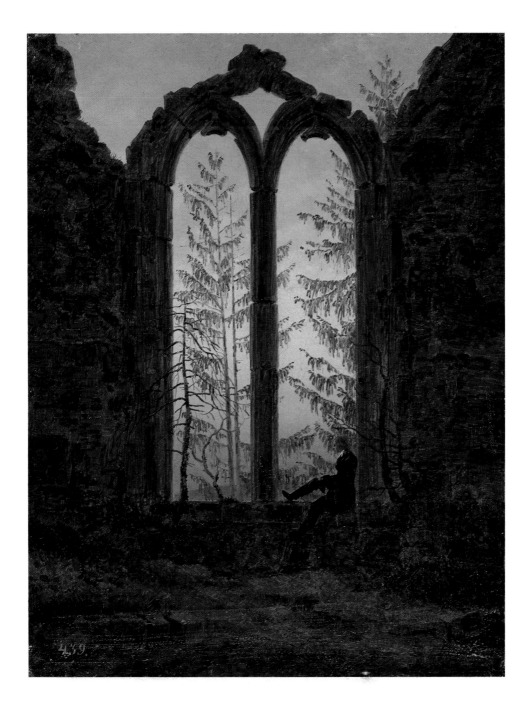

EXHIBITIONS
1974 Leningrad, no. 3; 1974 Hamburg,
no. 182; 1974–75 Dresden, no. 67; 1985
Moscow (unnumbered)

LITERATURE
Isergina 1956b, pp. 38–40; Hermitage cat-
alogue 1958, vol. 2, p. 347; Börsch-Supan
1960, p. 10 note 1; Eimer 1963, p. 26;
Prause 1963, pp. 46, 47; Hinz 1966, pp.
93, 107; Prause 1968, p. 32; Sumowski
1970, pp. 167, 234; Börsch-Supan and
Jähnig 1973, no. 451; Geismeier 1973,
pl. 57; Eimer 1974, p. 192; Börsch-Supan
1976, no. 233; Unverfehrt 1984, pl. 184;
Nikulin and Asvarishch 1986, no. 253;
Asvarishch 1988, no. 57

Owl in a Gothic Window
Eule in gotischem Fenster

1836
Pencil and sepia, bordered in black
ink; 14⅞ x 10¹/₁₆ in. (37.8 x 25.6 cm).
Signed, in a different hand, in pencil
(on reverse): *Friedrich*
State Hermitage Museum,
Leningrad. Inv. no. 43908. Acquired
in 1917

Friedrich often painted windows. He sits beside one in an early self-portrait, and in a famous back-view portrait of his wife—his only picture of her—she looks out of one (Nationalgalerie, Staatliche Museen Preussischer Kulturbesitz, Berlin). Others show views of the river Elbe or of a park. Friedrich's windows in Gothic ruins invite dreamers or, as here, an eagle owl, seen by the light of a full moon.

The bird stares at us. Oddly enough, it is the only creature in the artist's entire oeuvre to do so. With the exception of Friedrich's early self-portraits in which he looks at us—at himself, really, since he was working with a mirror—he showed all humans facing away from the viewer.

This owl stares at us once again, from atop a coffin, in the slightly later sepia drawing *Landscape with Grave, Coffin, and Owl,* ca. 1836–37 (Fig. 44). The window here is loosely based on a drawing Friedrich made while visiting the monastery on the Oybin mountain on July 4, 1810 (Fig. 42).

EXHIBITIONS
1836 Dresden, no. 283; 1837 Königsberg, no. 11; 1972 Vienna, no. 24; 1974 Leningrad, no. 24; 1974–75 Dresden, no. 229; 1985 Moscow (unnumbered)

LITERATURE
Isergina 1964, pp. 29–30, 31 (ill.); Hinz 1966, p. 60; Sumowski 1970, pp. 79, 151, 154, 232, ill. no. 325; Börsch-Supan and Jähnig 1973, no. 459, p. 44; Bernhard and Hofstätter 1974, p. 784; 1974–75 Dresden, p. 88; Siegel 1978, fig. 127, p. 130

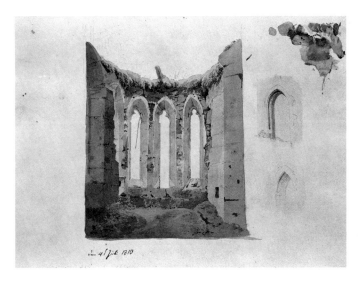

Fig. 42 Caspar David Friedrich, *Monastery Ruin on the Oybin Mountain,* July 4, 1810. Pencil and watercolor, 10¹/₁₆ x 14⅛ in. (25.5 x 35.8 cm). Hamburger Kunsthalle, Hamburg.

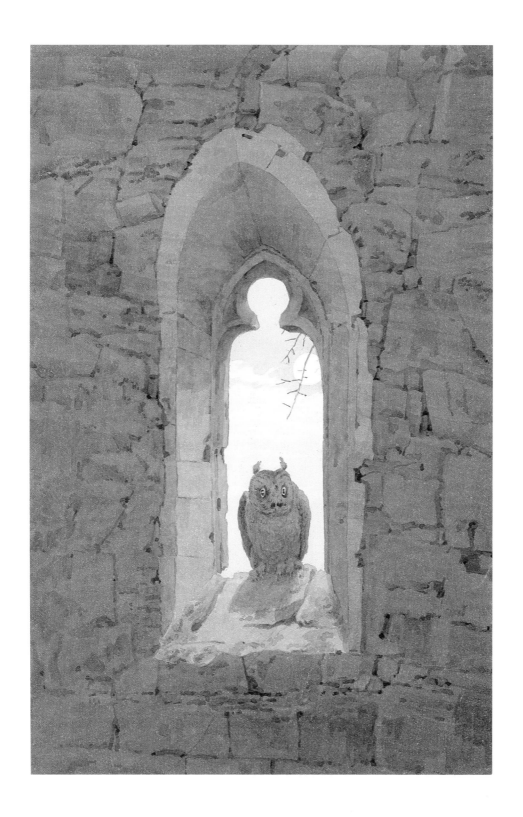

Coffin on a Grave
Sarg am Grab

ca. 1836
Pencil and sepia; 15⅜ x 15½ in.
(39.2 x 39.4 cm)
Pushkin State Museum of Fine Arts,
Moscow. Inv. no. 6241

While still in good health, the thirty-year-old Friedrich depicted a freshly dug grave, a newly inscribed tombstone, and mourners in a large, now lost, sepia drawing that he titled *My Funeral*, ca. 1803–4 (BS 112). Motifs of transience and death always captured this melancholic artist's imagination. Throughout his career, he painted ruins, crosses, cemeteries, and prehistoric tombs. After his stroke in 1835, however, some of these Romantic motifs became more bluntly direct. Owls sit on graves or coffins. Vultures perch on spades and peer into open graves. Here, a coffin propped on boards is ready to be lowered into the ground. At the time, such somewhat morbid elements were popular stock items of "Gothic" Romanticism.

In this work, Friedrich probably depicts the moment just before a burial. The mourners have not yet arrived—or perhaps there

Fig. 43 Caspar David Friedrich, *Coffin on a Grave*, ca. 1836. Pencil, 15⅞ x 15½ in. (40.3 x 39.4 cm). Hamburger Kunsthalle, Hamburg.

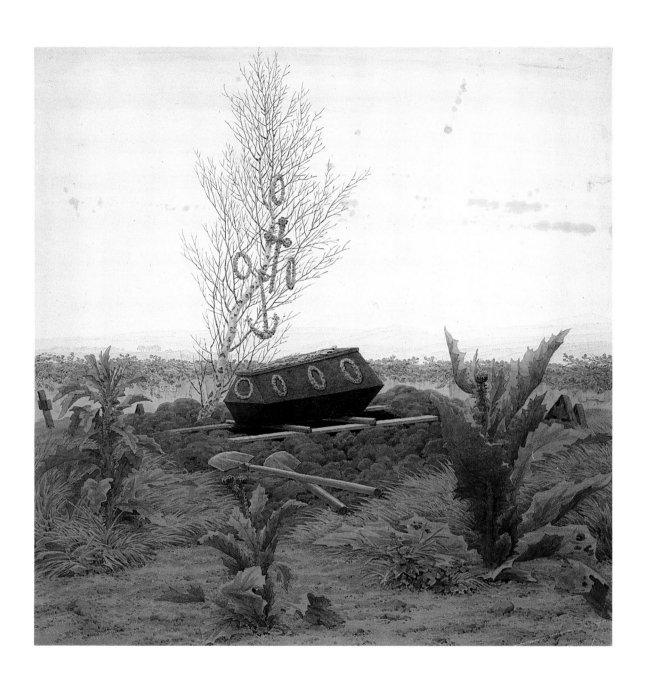

83

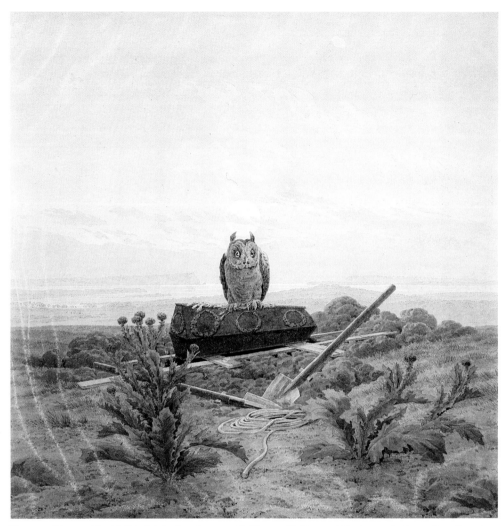

Fig. 44 Caspar David Friedrich, *Landscape with Grave, Coffin, and Owl*, ca. 1836–37. Pencil and sepia, 15¼ x 15¼ in. (38.5 x 38.5 cm). Hamburger Kunsthalle, Hamburg.

are none. The absence of human figures makes this starkly realistic image all the more haunting. Not even a bird is in sight. Friedrich's work predates by some fifteen years Courbet's monumental *Burial at Ornans*, 1850 (Musée d'Orsay, Paris), in which the French Realist rendered the mourners larger than life. In Courbet's picture, the open grave in the near foreground is barely indicated, whereas in the German Romanticist's work, death and its accessories loom large, and all life has vanished.

The vegetation of this rural northern German cemetery is appropriately grim. Three thorny thistles grow in the foreground, and a dead birch is hung with various funerary decorations: three wreaths, a cross, and an anchor. The deceased may have lost his life, and perhaps earned his livelihood, at sea.

The three thistles are based on three separate earlier pencil studies done from nature and dating from 1799 and 1813. A drawing from about 1836 served as the cartoon for the entire composition (Fig. 43).[1]

1. Börsch-Supan and Jähnig 1973, no. 461, pp. 462–63.

EXHIBITIONS
1974 Leningrad, no. 21; 1974 Hamburg, no. 226; 1975 Moscow–Leningrad, no. 5; 1978 Tokyo–Kyoto, no. 50; 1984 Paris, no. 370; 1985 Leningrad–Moscow, cat. p. 31

LITERATURE
Lioubimova 1966, p. 74; Sumowski 1970, pp. 62, 79, 155, 226, 236, fig. no. 328; Börsch-Supan and Jähnig 1973, no. 461; Bernhard and Hofstätter 1974, p. 373; Börsch-Supan 1976, fig. 24; Siegel 1978, fig. 129, p. 131; Eimer 1982, fig. 14; Hoch 1987, p. 92

Owl in Flight Before a Full Moon
Eule vor dem Mond

1836–37
Pencil and sepia, bordered in black
ink; 11 x 9⅝ in. (27.9 x 24.4 cm).
Watermark: *J. Whatman, Turkey Mill
1835*
State Hermitage Museum,
Leningrad. Inv. no. 43906.
Acquired in 1917

After his stroke in 1835 left him severely handicapped, Friedrich rarely painted in oil. Instead, he returned to sepia and watercolor, media that he had used exclusively until he took up oil painting in 1807.

Among the artist's predominantly somber themes of that time are a series of sepia drawings featuring the eagle owl. Friedrich often illuminated these night birds—symbols of death and bad luck, but also of wisdom—with the light of the full moon and placed them in a Gothic window, on a coffin, on a grave, or, as here, in the sky. The owl is identical to the one in *Owl on a Grave*, 1836–37 (p. 88), where its open wings look less natural than here, in flight.

EXHIBITIONS
1974 Leningrad, no. 22; 1975 Aarhus, no. 28; 1985 Moscow (unnumbered)

LITERATURE
Isergina 1964, pp. 29, 30 (ill.); Sumowski 1970, pp. 79, 89, 151, 155, 178, 195, 206, 225, 233, 235, 236, fig. no. 323; Börsch-Supan and Jähnig 1973, no. 462; Bernhard and Hofstätter 1974, p. 786; 1976–77 Paris, p. 75

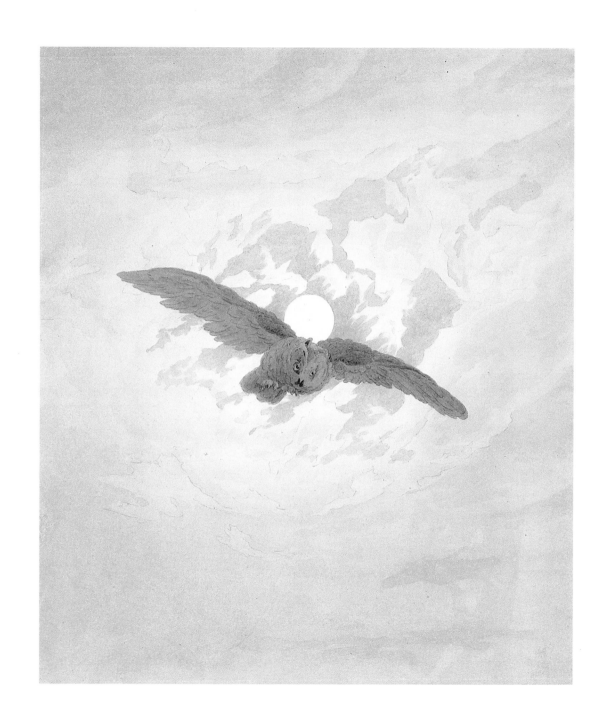

Owl on a Grave
Eule am Grab

1836–37
Pencil and sepia, bordered in black
ink; 10³⁄₁₆ x 8³⁄₄ in. (25.9 x
22.2 cm). Signed (lower left): *C.D.*
Friedrich
Pushkin State Museum of Fine Arts,
Moscow. Inv. no. 7283

The grave depicted in this drawing might be anywhere, in a ceme-
tery, in a field, or next to a roadside. The cross has been made out of
odd pieces of driftwood. Wildflowers add a picturesque touch.

As mentioned earlier, Friedrich would often draw on his "motif-
stock," which consisted of studies from nature that he had accumu-
lated over a period of time, in composing his pictures. The two
large flowers in the foreground, for example, are based on nature
studies dating as far back as 1799 (Kupferstichkabinett und Samm-
lungen der Zeichnungen, Staatliche Museen zu Berlin).[1] Friedrich
also used motifs more than once: the owl is identical to the one
featured in *Owl in Flight Before a Full Moon*, 1836–37 (p. 86). The
spread wings here may mean that the bird is about to take off. The
awkward position of the wings, which are too high and too far back
on the bird's body, indicates that Friedrich, although a most astute
observer of nature, was unaware of particulars of bird anatomy that
only became known after the invention of instantaneous photography.

1. Börsch-Supan and Jähnig 1973,
 p. 464.

EXHIBITIONS
1974 Leningrad, no. 23; 1974–75 Dres-
den, no. 230; 1975 Moscow–Leningrad,
no. 7; 1976–77 Paris, no. 85; 1984 Paris,
no. 369; 1985 Leningrad–Moscow, cat.
p. 31

LITERATURE
Geismeier 1966, p. 107 note 22; Lioubi-
mova 1966, p. 75; Sumowski 1970, pp.
79, 151, 155, fig. no. 329; Börsch-Supan
and Jähnig 1973, no. 463, p. 44; Bern-
hard and Hofstätter 1974, p. 785; Börsch-
Supan 1974, fig. 60; 1974–75 Dresden,
pp. 88, 239; Siegel 1978, fig. 128, p.
130; de Paz 1986, pp. 200–201, pl. 85

Two Men by the Sea at Moonrise
Zwei Männer bei Mondaufgang am Meer

ca. 1835–37
Pencil and sepia, bordered in black
ink; 9⅝ x 13⅝ in. (24.5 x 34.5 cm).
Signed, in a different hand, in pencil
(on reverse): *Friedrich*
State Hermitage Museum,
Leningrad. Inv. no. 43907.
Acquired in 1917

Friedrich liked the motif of a setting sun or rising moon over the sea watched by two men standing on a rocky beach. The theme first appears in a painting of 1818 (Nationalgalerie, Staatliche Museen Preussischer Kulturbesitz, Berlin) and is repeated in several works, including the two paintings *Moonrise by the Sea*, 1821 (p. 56), and *Evening Landscape with Two Men*, ca. 1830–35 (p. 74), and two sepia drawings of 1835–37, this one and another, in the collection of the Pushkin Museum (BS 478). The two men are identical to those in *Evening Landscape with Two Men*. The figures were copied (but reversed) from an earlier ink drawing of ca. 1815–18 (Fig. 41). In this picture, however, Friedrich placed the two figures farther apart.

As mentioned earlier, Friedrich's motionless figures are allegories for man's communion with nature—for the Romantics, a deeply spiritual communion. The spot where these two figures stand motionless, although impossible to identify, is probably somewhere on Friedrich's beloved island of Rügen. The German poet and theologian Gotthart Ludwig Theobul Kosegarten (1758–1818), whom Friedrich knew, had first rapturously evoked the island's sites in poetic outpourings composed in the then-ultrafashionable Ossianic mode. It was also Kosegarten who, in his famous *Uferpredigten* (*Beach Sermons*), first delivered on the shores of Rügen and later published, elevated the contemplation of nature to the status of divine worship. It may not be amiss to see Friedrich's two contemplative figures in such a Kosegartenesque context.

EXHIBITIONS
1968 Leningrad–Moscow, no. 73; 1970 Budapest, no. 43; 1972 Prague, no. 42; 1974 Hamburg (not in catalogue); 1974 Leningrad, no. 20; 1974–75 Dresden, no. 227; 1987 New Delhi, no. 109

LITERATURE
Isergina 1964, pp. 28, 30, 32 (ill.); Hinz 1966, p. 60; Sumowski 1970, pp. 79, 130, 155, 206, 227, 233, 236, fig. no. 324; Börsch-Supan and Jähnig 1973, no. 479; Bernhard and Hofstätter 1974, p. 782

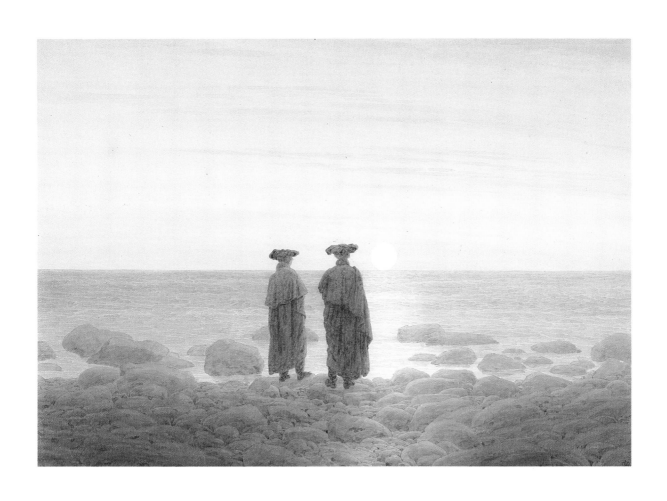

Boat on the Beach by Moonlight
Boot am Strand bei Mondlicht

1837–39
Pencil and sepia, bordered with black ink; 9⅝ x 16⅜ in. (24.4 x 41.6 cm).
Watermark: *J. Whatman Turkey Mill 1837*
State Hermitage Museum, Leningrad. Inv. no. 43910.
Acquired after 1917

The painter Wilhelm von Kügelgen (1802–1867), who often saw Friedrich in Dresden, wrote of the latter's work: "It is a pity that one cannot describe works of art: actually, one can only indicate their subject matter. The subjects Friedrich painted were very odd. He did not represent paradisiacal places, full of riches and splendors, as those beloved by Claude and favored by those who care only for material things. Extremely simple, barren, serious, and melancholy, Friedrich's imaginary pictures correspond rather to the songs of that Old Celtic bard [Ossian] that told of fog, mountain heights, and moorlands. An ocean of fog from which a single rock reaches up for the sun, a desolate beach by moonlight, a shipwreck in a sea of ice, these and similar things Friedrich painted and breathed into them a strange life."[1]

Kügelgen's words would seem to apply to a group of sepia drawings dating from the end of Friedrich's life that depict a deserted beach by moonlight. Devoid of any figures, they feature only rocks—or rocks with an anchor or, as here, with a boat pulled onto a rocky shore. Friedrich had first visited the island of Rügen about 1798–99. During a later visit to the island in June 1801, he executed a drawing (Kupferstichkabinett, Staatliche Kunstsammlungen Dresden) showing a beach and boat in the foreground with a view of the rocky cliffs of Arcona, the northernmost point of the island, in the far background and a tree-covered slope rising on the left. That drawing served as the model for a group of sepia drawings Friedrich made about 1805. The present work is also based on the 1801 drawing, but it only uses the right side of the earlier composition.

1. Wilhelm von Kügelgen, *Jugenderinnerungen eines alten Mannes,* ed. and with a foreword by Adolf Stern (Leipzig, 1903), p. 151. Translation here by Sabine Rewald. Wilhelm von Kügelgen was the son of Gerhard von Kügelgen (see p. 44).

EXHIBITIONS
1974 Leningrad, no. 25; 1974–75 Dresden, no. 231; 1985 Moscow (unnumbered); 1987 Sapporo, no. 64

LITERATURE
Isergina 1964, pp. 28–29 (ill.), 29; Hinz 1966, p. 60; Sumowski 1970, pp. 79, 89, 151, 152, 155, 226, 233, 237, fig. no. 322; Börsch-Supan and Jähnig 1973, no. 486, p. 44; Bernhard and Hofstätter 1974, p. 781; 1974–75 Dresden, pp. 239, 242

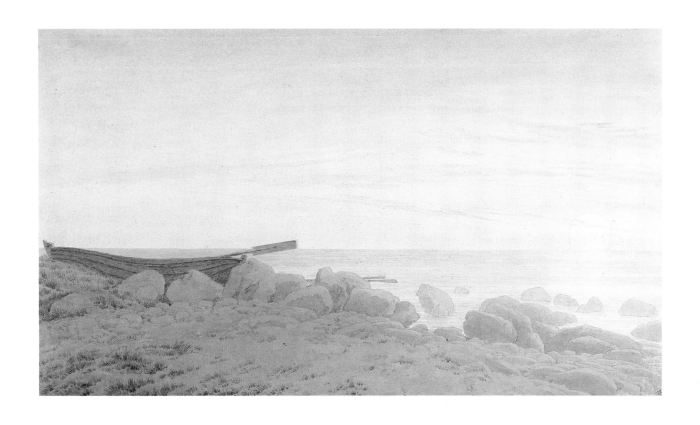

The "Gate" on the Neurathen
Das Tor auf dem Neurathen

ca. 1837–40
Watercolor and pencil; bordered in
black ink; 11 x 9⅝ in. (27.9 x 24.5 cm).
Signed, in a different hand (on the
mount): *Friedrich*
State Hermitage Museum,
Leningrad. Inv. no. 46033.
Acquired in 1969

The mountains of the Elbsandsteingebirge were among the handful of regions in Germany and Bohemia that Friedrich chose to depict in his work. Also called Saxon Switzerland because of its popularity with Swiss painters during the eighteenth century, the mountains rise on both sides of the river Elbe and extend down to the border of present-day Czechoslovakia. The Elbe and its affluents have worn deep beds in the area's sandstone rocks. Wind and rain have carved the rocky walls into picturesque forms like the "Gate" on the Neurathen mountain shown in this watercolor. The Elbe, barely visible in the distance, makes a broad loop at this site near the town of Rathen and east of Pirna. It is one of the finest points of Saxon Switzerland, where "the view is magnificent, affording an adorable survey of the wooded gorges and of the abrupt peaks resembling gigantic castles."[1]

Friedrich had previously included the bizarre-looking "Gate" as a backdrop in his painting *Ravine*, ca. 1822–23 (Kunsthistorisches Museum, Vienna). The two faintly visible mountains rising in the far background in this watercolor—the Rosenberg on the left and the Zirkelstein on the right—are based on a drawing of August 12, 1808, which Friedrich probably made while visiting this region.

1. Karl Baedeker, *Northern Germany Excluding the Rhineland* (Leipzig, 1925), p. 192.

EXHIBITIONS
1974 Leningrad, no. 15; 1974 Hamburg (not in catalogue); 1974–75 Dresden, no. 223; 1977 Leningrad, no. 150; 1979 Leningrad, no. 93; 1985 Moscow (unnumbered)

LITERATURE
Börsch-Supan and Jähnig 1973, no. 495; Bernhard and Hofstätter 1974, p. 779; Kuznezow 1974

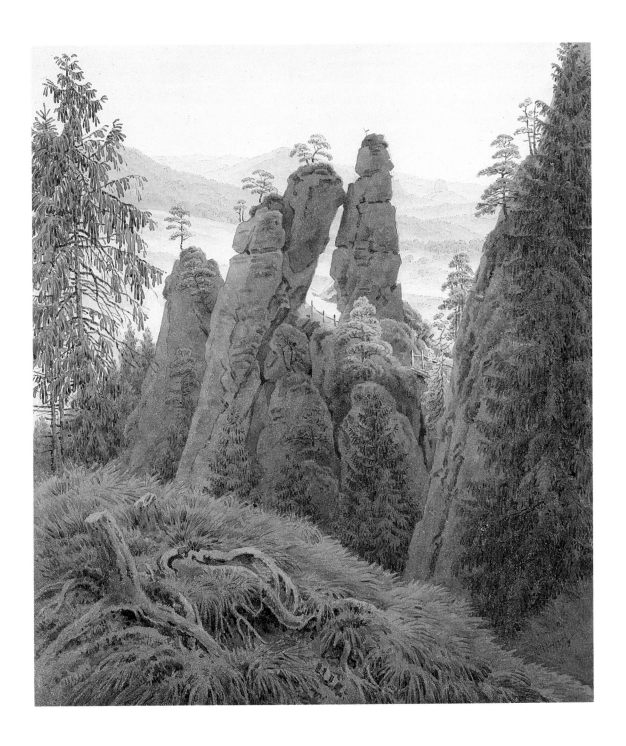

Fig. 45 Georg Friedrich Kersting, *Caspar David Friedrich on His Walking Tour
Through the Riesengebirge*, 1810. Watercolor and pencil on blue tinted paper, 12¼
x 9⅝ in. (31 x 24.5 cm). Nationalgalerie, Sammlung der Zeichnungen, Staatliche
Museen zu Berlin.

Exhibitions and Related Publications

1820 Dresden
Dresdner Akademische Kunstausstellung. Dresden, Königliche Sächsische Akademie der Künste, from Aug. 3, 1820.

1821 Dresden
Dresdner Akademische Kunstausstellung. Dresden, Königliche Sächsische Akademie der Künste, from Aug. 3, 1821.

1823 Dresden
Dresdner Akademische Kunstausstellung. Dresden, Königliche Sächsische Akademie der Künste, from Aug. 3, 1823.

1824 Prague
Kunstausstellung in der Akademie zu Prag. Prague, early 1824.

1832 Prague
Exhibition organized by Professor Aloys Klar. Prague, Mar. 1832.

1835 Dresden
Dresdner Akademische Kunstausstellung. Dresden, Königliche Sächsische Akademie der Künste, from Aug. 2, 1835.

1836 Dresden
Dresdner Akademische Kunstausstellung. Dresden, Königliche Sächsische Akademie der Künste, from July 31, 1836.

1837 Königsberg
Verzeichnis der 7. Kunst- und Gewerbeausstellung in Königsberg. 1837.

1958 Stralsund
Nordostdeutsche Küstenlandschaft von Hackert bis zur Gegenwart. Catalogue by Werner Sumowski. Stralsund, Kulturhistorisches Museum, 1958.

1963 Moscow
Zhivopis' i risunok v Germanii i Avstrii ot XV po XIX v [Painting and drawing in Germany and Austria from the fifteenth to the nineteenth century]. Moscow, Pushkin State Museum of Fine Arts, 1963.

1964 Heidelberg
Kunst in Dresden, 18.–20. Jahrhundert, Aquarelle, Zeichnungen, Druckgraphik: Ausstellung zur Erinnerung an die Gründung der Dresdner Kunstakademie 1764. Heidelberg, Kurpfälzisches Museum, Sept. 6–Nov. 1, 1964. Catalogue by J. C. Jensen.

1965 Berlin
Deutsche Romantik: Gemälde und Zeichnungen. Berlin, Nationalgalerie, Staatliche Museen zu Berlin, 1965. Catalogue with an essay by Willi Geismeier.

1968 Leningrad–Moscow
Ot Diurera do Pikasso: 50 let sobraniia i izucheniia zapadnoevropeiskogo risunka v Gosudarstvennom Ermitazhe [From Dürer to Picasso: Fifty years of collecting and studying Western European drawing at the State Hermitage Museum]. Leningrad, State Hermitage Museum, 1968.

1970 Budapest
Kiállitas a Leningradi Ermitász legeszelb rajzaibol. Budapest, Szépmüvészeti Múzeum, 1970.

1970 Leningrad
Exhibition of New Acquisitions of the State Hermitage Museum, 1959–1969. Leningrad, State Hermitage Museum, 1970.

1970 New Haven–Cleveland–Chicago
German Painting of the 19th Century. New Haven, Yale University Art Gallery, Oct. 15–Nov. 22, 1970; Cleveland Museum of Art, Dec. 9, 1970–Jan. 24, 1971; Art Institute of Chicago, Feb. 27–Mar. 28, 1971. Catalogue by Kermit S. Champa with Kate H. Champa.

1972 London
Caspar David Friedrich 1774–1840: Romantic Landscape Painting in Dresden. London, Tate Gallery, 1972. Catalogue by William Vaughan, Helmut Börsch-Supan, and Hans Joachim Neidhardt.

1972 Prague
Kresby europskych mistrû XV–XX st. se sbirek statni Ermitage v Leningrade [Drawings by European masters from the fifteenth through twentieth centuries from the collection of the Hermitage in Leningrad]. Prague, Národní Galerie, 1972.

1972 Vienna
Meisterzeichnungen aus der Ermitage in Leningrad, dem Puschkin Museum und der Tretjakow Galerie in Moskau. Vienna, Graphische Sammlung Albertina, 1972.

1974 Hamburg
Caspar David Friedrich 1774–1840. Hamburg, Hamburger Kunsthalle, Sept. 14–Nov. 3, 1974. Catalogue with essays by Werner Hofmann, Siegmar Holsten, Hans Werner Grohn, Eleonore Reichert, and Eckhard Schaar.

1974 Leningrad
Kaspar David Fridrikh i romanticheskaia zhivopis' ego vremeni [Caspar David Friedrich and the Romantic painting of his time]. Leningrad, State Hermitage Museum, from July 19, 1974.

1974–75 Dresden
Caspar David Friedrich und sein Kreis, Dresden, Gemäldegalerie Neue Meister, Staatliche Kunstsammlungen Dresden. Nov. 24, 1974–Feb. 16, 1975. Catalogue with essays by Irma Emmrich, Peter H. Feist, and Hans Joachim Neidhardt.

1975 Aarhus
Tegninger fra det Statslige Eremitagemuseum og det Statslige Russiske Museum. Aarhus (Denmark), Kunstmuseum, June 1–29, 1975.

1975 Moscow–Leningrad

Kaspar David Fridrikh (1774–1840) i ego sovremenniki [Caspar David Friedrich and his contemporaries]. Moscow, Pushkin State Museum of Fine Arts; Leningrad, State Hermitage Museum, 1975.

1976–77 Paris

La Peinture allemande à l'époque du Romantisme. Paris, Orangerie des Tuileries, Oct. 25, 1976–Feb. 28, 1977.

1977 Leningrad

Novye postupleniia 1966–1977 [New acquisitions 1966–1977]. Leningrad, State Hermitage Museum, 1977.

1978 Bonn

Meisterwerke deutscher und russischer Malerei aus sowjetischen Museen. Bonn, Rheinisches Landesmuseum, 1978.

1978 Tokyo–Kyoto

Caspar David Friedrich und sein Kreis: Eine Ausstellung aus der Deutschen Demokratischen Republik. Tokyo, National Museum for Modern Art, Feb. 11–Apr. 2, 1978; Kyoto, National Museum, Apr. 8–May 28, 1978. Catalogue in German and Japanese.

1979 Leningrad

Vidovoi risunok zapadnoevropeiskikh khudozhnikov XIX veka iz sobraniia Ermitazha [Landscape drawing by Western European artists of the nineteenth century from the collection of the Hermitage]. Leningrad, State Hermitage Museum, 1979.

1980 Oslo

Dahls Dresden. Oslo, Nasjonalgalleriet, 1980.

1981 New York–Ontario

German Masters of the Nineteenth Century: Paintings and Drawings from the Federal Republic of Germany. New York, The Metropolitan Museum of Art, May 2–July 5, 1981; Ontario, Art Gallery of Ontario, Aug. 1–Oct. 11, 1981. Catalogue with essays by Gert Schiff and Stephan Waetzoldt.

1981 Stockholm

Romantiken i Dresden: Caspar David Friedrich och hans samtida 1800–1850. Stockholm, Nationalmuseum, 1981.

1984 Paris

Caspar David Friedrich: Le tracé et la transparence. Paris, Centre Culturel du Marais, 1984.

1985 Bern

Traum und Wahrheit: Deutsche Romantik aus Museen der Deutschen Demokratischen Republik. Kunstmuseum Bern, May 24–Aug. 4, 1985. Catalogue with essays by Willi Geismeier, Jürgen Glaesemer, Josef Helfenstein, Hans Joachim Neidhardt, Hans Christoph von Tavel, and Christa Wolf.

1985 Leningrad–Moscow

Mir romantizma: Zhivopis', risunok [The world of Romanticism: Painting and drawing]. Leningrad, State Hermitage Museum; Moscow, Pushkin State Museum of Fine Arts, 1985.

1985 Munich
Deutsche Romantiker: Bildthemen der Zeit von 1800 bis 1850. Munich, Kunsthalle der Hypo-Kulturstiftung, 1985.

1987 Hamburg
Deutsche Malerei aus der Ermitage. Hamburg, Hamburger Kunsthalle, May 27–July 12, 1987.

1987 New Delhi
Masterpieces of Western European Art from the Hermitage, Leningrad. New Delhi, National Museum, 1987.

1987 Sapporo
Proizvedeniia zapadnoevropeiskikh masterov XIX–XX vekov iz sobraniia Ermitazha [Works by Western European masters of the nineteenth and twentieth centuries from the collection of the Hermitage]. Sapporo, Hokkaido Museum of Modern Art, 1987. Catalogue in Russian and Japanese.

1989 Vienna
Wunderblock: Eine Geschichte der modernen Seele. Vienna, Wiener Festwochen/ Historisches Museum der Stadt Wien, Apr. 27–Aug. 6, 1989.

1990 Essen
St. Petersburg um 1800: Ein goldenes Zeitalter des russischen Zarenreichs. Essen, Villa Hügel (Kulturstiftung Ruhr), June 9–Nov. 4, 1990.

1990 London
Caspar David Friedrich: Winter Landscape. London, National Gallery, Mar. 28–May 28, 1990. Catalogue with essays by John Leighton and Colin J. Bailey.

Bibliography

In Börsch-Supan and Jähnig 1973, all nineteenth-century sources given below are reprinted in full, and twentieth-century literature is selectively excerpted. For exhibition-related publications, see Exhibitions and Related Publications.

Archiv für Geschichte 1824
Anonymous. [Concerning the 1824 Prague exhibition.] *Archiv für Geschichte, Statistik, Literatur und Kunst* 15 (1824): 377.

Artistisches Notizenblatt 1832
Anonymous. "Prager und Wiener Kunstausstellung." *Artistisches Notizenblatt* (1832): 37–38.

Asvarishch 1985
Boris I. Asvarishch. *Caspar David Friedrich.* Masters of World Painting. Leningrad, 1985.

Asvarishch 1988
———. *German and Austrian Painting: Nineteenth and Twentieth Centuries.* Ed. by Olga N. Nechipurenko. The Hermitage Catalogue of Western European Painting, 15. Florence, 1988.

Bernhard 1974
Marianne Bernhard, ed. *Deutsche Romantik Handzeichnungen.* Essay by Petra Kipphoff. 2d ed. [Munich, 1974].

Bernhard and Hofstätter 1974
Marianne Bernhard, ed. *Caspar David Friedrich: Das gesamte graphische Werk.* Essay by Hans H. Hofstätter. Munich, 1974.

Börsch-Supan 1960
Helmut Börsch-Supan. *Die Bildgestaltung bei Caspar David Friedrich.* Munich, 1960. [Ph.D. diss., Berlin, 1958].

Börsch-Supan 1969
———. "Caspar David Friedrichs Gedächtnisbild für den Berliner Arzt Johann Emanuel Bremer." *Pantheon* 27 (1969): 399–409.

Börsch-Supan 1970
———. "*Einsamer Baum* und *Mondaufgang am Meer:* Zu zwei Gemälden Caspar David Friedrichs." *Kunstgeschichtliche Gesellschaft zu Berlin: Sitzungsberichte,* n.s. 18 (1970): 16–17.

Börsch-Supan 1972
———. "Caspar David Friedrich's Landscapes with Self-Portraits." *Burlington Magazine* 114 (1972): 620–30.

Börsch-Supan 1974
———. *Caspar David Friedrich*. New York, 1974.

Börsch-Supan 1976
———. *L'opera completa di Friedrich*. Classici dell'arte, 84. Milan, 1976.

Börsch-Supan 1980
———. *Caspar David Friedrich*. Munich, 1980.

Börsch-Supan and Jähnig 1973
Helmut Börsch-Supan and Karl Wilhelm Jähnig. *Caspar David Friedrich: Gemälde, Druckgraphik und bildmässige Zeichnungen*. Munich, 1973.

Boetticher 1891
Friedrich von Boetticher. *Malerwerke des Neunzehnten Jahrhunderts*. Vol. 1. Dresden, 1891. Reprint, Hofheim/Taunus, 1974.

Böttiger 1820
Böttiger. [Concerning the 1820 Dresden exhibition.] *Dresdner Abendzeitung, Wegweiser im Gebiete der Künste und Wissenschaften*, Oct. 14, 1820.

Böttiger 1822
———. "Kunstnachrichten aus Dresden." *Artistisches Notizenblatt* (Jan. 17, 1822): 5.

Böttiger 1823
———. "Kunstnachrichten aus Dresden: Landschaften auf der jetzigen Ausstellung." *Artistisches Notizenblatt* (1823): 64.

Böttiger 1824
———. "Die Dresdner Kunstausstellung." *Artistisches Notizenblatt* (1824): 59.

Eimer 1960
Gerhard Eimer. "Caspar David Friedrichs *Auf dem Segler*." *Zeitschrift für Ostforschung* 9 (1960): 230–41.

Eimer 1963
———. *Caspar David Friedrich und die Gotik: Analysen und Deutungsversuche aus Stockholmer Vorlesungen*. Hamburg, 1963.

Eimer 1974
———. *Caspar David Friedrich, Auge und Landschaft: Zeugnisse in Bild und Wort*. Frankfurt am Main, 1974.

Eimer 1982
———. *Zur Dialektik des Glaubens bei Caspar David Friedrich*. Frankfurter Fundamente der Kunstgeschichte, 1. Frankfurt am Main, 1982.

Einem 1938
Herbert von Einem. *Caspar David Friedrich*. Kunstbücher des Volkes, 26. Berlin, [1938].

Einem 1939
———. "Wassilij Andrejewitsch Joukowski und C. D. Friedrich." In *Das Werk des Künstlers*, pp. 169–84. Stuttgart, 1939.

Emmrich 1964
Irma Emmrich. *Caspar David Friedrich*. Weimar, 1964.

Feist 1956
Peter H. Feist. "Der Hallmarkt als Hafen: Zu einem Gemälde von C. D. Friedrich." *Hallesches Monatsheft* 3, no. 11 (1956): 449–52.

Geismeier 1965
Willi Geismeier, "Die Staffage bei Caspar David Friedrich." *Staatliche Museen zu Berlin: Forschungen und Berichte* 7 (1965): 54–57.

Geismeier 1966
———. *Deutsche Malerei des 19. Jahrhunderts*. Leipzig, 1966.

Geismeier 1973
———. *Caspar David Friedrich*. Leipzig, 1973. Reprint, Vienna–Munich, 1975.

Geismeier 1988
———. *Caspar David Friedrich*. 2d ed. Leipzig, 1988.

Gesellschafter 1821
C. [Concerning the 1821 Dresden exhibition.] *Der Gesellschafter oder Blätter für Geist und Herz* (1821): 773.

Gesellschafter 1823
St. [Concerning the 1823 Dresden exhibition.] *Der Gesellschafter oder Blätter für Geist und Herz* (1823): 683.

Gesellschafter 1824
X. "Zeitung der Ereignisse und der Ansichten: Prag." [Concerning the 1824 Prague exhibition.] *Der Gesellschafter oder Blätter für Geist und Herz* (1824): 352.

Grundmann 1965
Günther Grundmann. *Das Riesengebirge in der Malerei der Romantik*. 3d, enl. ed. Munich–Pasing, 1965.

Heider 1963
G. Heider. "Unbekannte Briefe C. D. Friedrichs an W. A. Shukowski zur Transparentmalerei." *Wissenschaftliche Zeitschrift der Karl-Marx-Universität Leipzig: Gesellschafts- und sprachwissenschaftliche Reihe* 12 (1963): 373–79.

Hermitage catalogue 1958
Musée de l'Ermitage, Leningrad: Département de l'art occidental. Catalogues des peintures, 2. Leningrad–Moscow, 1958.

Hinz 1976
Berthold Hinz, ed. *Bürgerliche Revolution und Romantik: Natur und Gesellschaft bei Caspar David Friedrich*. Giessen, 1976.

Hinz 1964
Sigrid Hinz. "Zur Datierung der norddeutschen Landschaften Caspar David Friedrichs." *Greifswald-Stralsunder Jahrbuch* 4 (1964): 241–68.

Hinz 1966
———. "Caspar David Friedrich als Zeichner: Ein Beitrag zur stilistischen Entwicklung der Zeichnungen und ihre Bedeutung für die Datierung der Gemälde." Ph.D. diss., Greifswald, 1966.

Hinz 1968
———, ed. *Caspar David Friedrich in Briefen und Bekenntnissen*. Berlin, 1968. Rev. and enl. ed., Munich, 1974.

Hoch 1985
Karl-Ludwig Hoch, ed. *Caspar David Friedrich—unbekannte Dokumente seines Lebens*. Dresden, 1985.

Hoch 1987
———. *Caspar David Friedrich in Böhmen: Bergsymbolik in der romantischen Malerei*. Dresden, 1987.

Hofmann 1988
Werner Hofmann. "Der Kontext hat das letzte Wort." *IDEA, Jahrbuch der Hamburger Kunsthalle* 8 (1988): 67–74.

Isergina 1956a
Antonina N. Isergina. "Unbekannte Bilder von Caspar David Friedrich." *Bildende Kunst* 5 (1956): 263–66, 275–76.

Isergina 1956b
———. [A picture by Carl Gustav Carus in the Hermitage.] *Soobshcheniia Gosudarstvennogo Ermitaza* 9 (1956): 38–40.

Isergina 1964
———. [Drawings by Caspar David Friedrich.] *Bulletin du Musée de l'Ermitage* (1964): 28–33.

Jensen 1978
Jens Christian Jensen. *Aquarelle und Zeichnungen der deutschen Romantik*. Cologne, 1978.

Kostenevich 1976
Albert Kostenevich, ed. *The Hermitage: Western European Painting of the Nineteenth and Twentieth Centuries*. Introduction and notes by Albert Kostenevich. Trans. by N. Johnstone and H. Perham. Leningrad, 1976.

Kostenevich 1987
———, ed. *Western European Painting in the Hermitage: 19th–20th Centuries*. Trans. by H. Hoggenbom, K. Carroll, R. Singer, and N. Fiodorova. Leningrad, 1987.

Kunst 1974
Hans-Joachim Kunst. "Caspar David Friedrich und die Gotik." *Kritische Berichte* 2, nos. 5–6 (1974): 120–29.

Kunstblatt 1820
Anonymous. "Über die diesjährige Kunstausstellung in Dresden." *Kunstblatt* [ed. by L. Schorn] 1 (1820): 377, 380.

Kunstblatt 1824
Anonymous. "Die Kunstausstellung zu Prag im Jahr 1824." *Kunstblatt* 5 (1824): 208.

Kuznezow 1974
Iuriĭ Kuznezow. "Risunok Kaspara Davida Fridrikha" [A drawing by Caspar David Friedrich]. *Soobshcheniia Gosudarstvennogo Ermitazha* 39 (1974).

Licio 1823
Filodemo Licio. "Kurze Nachricht von der diesjährigen Dresdner Kunstausstellung." *Deutsche Blätter für Poesie, Litteratur, Kunst und Theater* (1823): 610.

Liebmann 1957a
M[ichael] T. Liebmann. "Akvareli Kaspara Davida Fridrikha v sobranii Gos. Museia Izobrazitel'nykh Iskusstv im. A. S. Pushkina v Moskve" [Watercolors of Caspar David Friedrich in the collection of the Pushkin State Museum of Fine Arts, Moscow]. *Soobshcheniia Instituta istorii iskusstv Akademii Nauk SSSR* 8 (1957): 136–46.

Liebmann 1957b
———. "Neuentdeckte Aquarelle von Caspar David Friedrich." *Bildende Kunst* 8 (1957): 532–33.

Linnik 1977
The Hermitage: Western European Painting. Compiled and annotated by I. Linnik. Trans. by Iu. Pamfilov and Iu. Nemetskiĭ. Leningrad, 1977.

Lioubimova 1966
E. L. Lioubimova. "Dessins inédits de K. D. Friedrich dans la collection du Musée des Beaux-Arts Pouchkine." *Soobshcheniia Gosudarstvennogo Muzeia Izobrazitel'nykh Iskusstv* 3 (1966): 74–76.

Literarisches Conversationsblatt 1821
Anonymous. [Concerning the 1820 Dresden exhibition.] *Literarisches Conversationsblatt* (1821): 39.

Literarisches Conversationsblatt 1823
Anonymous. [Concerning the 1823 Dresden exhibition.] *Literarisches Conversationsblatt* (1823): 965–66.

Märker 1974
Peter Märker. *Geschichte als Natur: Untersuchungen zur Entwicklungsvorstellung bei Caspar David Friedrich.* Ph.D. diss., Kiel, 1974.

Masaryková 1964
Anna Masaryková. "Obrazy K. D. Fridrikha a F. Ch. Dahla v Praze v roce 1824" [Paintings of C. D. Friedrich and F. C. Dahl in Prague in 1824]. *Umění* 12 (1964): 99 ff.

Merkur 1824
Anonymous. [Concerning the 1824 Prague exhibition.] *Merkur: Mittheilungen aus Vorräthen der Heimath und der Fremde für Wissenschaft und Kunst* (1824): 239.

Nikulin and Asvarishch 1986
The Hermitage: German and Austrian Painting. Introductory articles and notes on the plates by Nikolai Nikulin and Boris Asvarishch. Trans. by D. Pliukhin, M. Stronin, A. Miyokan, and H. Aplin. Leningrad, 1986.

de Paz 1986
Alfredo de Paz. *Lo sguardo interiore: Friedrich o della pittura romantica tedesca.* Romantismo e dintorni, 2. Naples, 1986.

Prause 1963
Marianne Prause. *Carl Gustav Carus als Maler.* Ph.D. diss., Cologne, 1963.

Prause 1968
———. *Carl Gustav Carus: Leben und Werk.* Berlin, 1968.

Rautmann 1979
Peter Rautmann. *Caspar David Friedrich: Landschaft als Sinnbild entfalteter bürgerlicher Wirklichkeitsaneignung.* Kunstwissenschaftliche Studien, 7. Frankfurt am Main–Bern–Las Vegas, 1979.

Rosenblum 1975
Robert Rosenblum. *Modern Painting and the Northern Romantic Tradition: Friedrich to Rothko.* New York–Evanston–San Francisco–London, 1975.

Schmied 1975
Wieland Schmied. *Caspar David Friedrich.* Cologne, 1975.

Siegel 1978
Linda Siegel. *Caspar David Friedrich and the Age of German Romanticism.* Foreword by George Levitine. Boston, 1978.

Sigismund 1943
Ernst Sigismund. *Caspar David Friedrich: Eine Umrisszeichnung.* Dresden, 1943.

Sumowski 1966
Werner Sumowski. "Gotische Dome bei Caspar David Friedrich." In *Klassizismus und Romantik in Deutschland: Gemälde und Zeichnungen aus der Sammlung Georg Schäfer, Schweinfurt,* exh. cat. (Nuremberg: Germanisches Nationalmuseum, July 1–Oct. 2, 1966), pp. 39–42.

Sumowksi 1970
———. *Caspar David Friedrich-Studien.* Wiesbaden, 1970.

Unverfehrt 1984
Gerd Unverfehrt. *Caspar David Friedrich.* Munich, 1984.

Vaughan 1980
William Vaughan. *German Romantic Painting.* New Haven–London, 1980.

Walther 1983
Angelo Walther. *Caspar David Friedrich.* Welt der Kunst. Berlin, 1983.

Wiener Zeitschrift 1820
Anonymous. [Concerning the 1820 Dresden exhibition.] *Wiener Zeitschrift für Kunst, Literatur, Theater und Mode* (1820): 990.

Wiener Zeitschrift 1821
Anonymous. "Über die Dresdner Kunstausstellung im August 1821." *Wiener Zeitschrift für Kunst, Literatur, Theater und Mode* (1821): 975, 997, 998.

Wiener Zeitschrift 1823
Anonymous. [Concerning the 1823 Dresden exhibition.] *Wiener Zeitschrift für Kunst, Literatur, Theater und Mode* (1823): 1070.

Wiener Zeitschrift 1824
Anonymous. "Correspondenz Nachricht: Prag Ende Juny." *Wiener Zeitschrift für Kunst, Literatur, Theater und Mode* (1824): 780.

Wiener Zeitschrift 1835
Anonymous. "Über die Dresdner Kunstausstellung im Herbst." *Wiener Zeitschrift für Kunst, Literatur, Theater und Mode* (1835): 1003.

Wolfradt 1924
Willi Wolfradt. *Caspar David Friedrich und die Landschaft der Romantik*. Berlin, 1924.

Chronology

This chronology is based on those given in Börsch-Supan and Jähnig 1973, pp. 11–12, and *Caspar David Friedrich 1774–1840,* Kunst um 1800, exh. cat. (Hamburg: Hamburger Kunsthalle, 1974), pp. 83–88.

1774	Caspar David Friedrich is born on September 5 in Greifswald, on the Baltic Sea. He is one of eight children of Adolf Gottlieb Friedrich, a soap- and candlemaker, and Sophie Dorothea Friedrich, née Bechly.
1781	Friedrich's mother dies on March 7.
1782	His sister Elisabeth dies on February 18.
1787	On December 8, Friedrich's younger brother Johann Christoffer drowns in an ice-skating accident.
1790	Friedrich begins drawing lessons with Johann Gottfried Quistorp, drawing teacher at the University of Greifswald.
1791	His sister Maria dies on May 27.
1794–98	Friedrich studies at the Copenhagen Art Academy. His teachers include Nicolai Abraham Abildgaard, Jens Juel, Christian August Lorentzen, and Johannes Wiedewelt. Leaves Copenhagen in May and moves to Dresden.
1799	Participates for the first time, with a watercolor, in the annual exhibition of the Dresden Academy.
1801–2	In the spring, Friedrich returns to Greifswald. His stay, which lasts until the following summer, is interrupted by several trips to Rügen, an island he first visited in 1798–99. Makes landscape drawings. In Greifswald Friedrich meets Philipp Otto Runge.
1803	Friedrich rents a modest summer place at Loschwitz, near Dresden.
1805	In May his friend the painter Gerhard von Kügelgen settles in Dresden. Friedrich sends two drawings, at Goethe's suggestion, to the Weimarer Kunstfreunde (Weimar Friends of the Arts) and is awarded a prize for them.
1806	Illness. In April Friedrich travels to Greifswald via Neubrandenburg. The trip lasts through August and includes a stay on the island of Rügen.
1807	In August and September, Friedrich travels in northern Bohemia. Paints *View of the Elbe Valley.*

1808	Another trip to northern Bohemia. At Christmas, Friedrich exhibits *The Cross in the Mountains (Tetschen Altarpiece)* (Fig. 26) in his apartment. The work is criticized by Basilius von Ramdohr.
1809	Trips to Greifswald and Neubrandenburg. Friedrich's father dies on November 6.
1810	In July Friedrich explores the Riesengebirge on foot with his friend the painter Georg Friedrich Kersting. Goethe visits Friedrich on September 18. Friedrich exhibits *The Monk by the Sea* (Fig. 27) and *Abbey in the Oak Forest* at the Berlin Academy, where they are seen and purchased by the Prussian crown prince. Elected a member of the Berlin Academy.
1811	In June Friedrich and the sculptor Gottlieb Christian Kühn hike through the Harz Mountains. Friedrich visits Goethe in Jena on his way back. Completes *Morning in the Riesengebirge* (Fig. 25).
1812	Frederick William III of Prussia purchases *Morning in the Riesengebirge* while it is exhibited in Weimar. Friedrich paints *Tombs of the Freedomfighters*.
1813	Waits out Dresden's occupation by French troops in the Elbsandsteingebirge (Saxon Switzerland).
1814	Visits the Plauenscher Grund in Thuringia.
1815	Friedrich spends August and September in Greifswald and on Rügen. Paints *The Cross on the Baltic Sea*.
1816	Becomes member of the Dresden Academy.
1817	Meets the physician and painter Carl Gustav Carus.
1818	On January 21, Friedrich marries Caroline Bommer. The couple travels to Greifswald, Wolgast, Stralsund, and Rügen. On September 28, the Norwegian painter Johan Christian Clausen Dahl arrives in Dresden and seeks Friedrich's acquaintance. Friedrich paints *Wanderer Above a Sea of Fog* and *Chalk Cliffs on Rügen* (Fig. 30).
1819	Visit by Prince Christian Frederick of Denmark on July 12. Friedrich's daughter Emma is born on August 30. Paints *Two Men Contemplating the Moon*.
1820	Gerhard von Kügelgen is murdered on March 27 on his way from Dresden to Loschwitz by a soldier turned highwayman. Friedrich moves to a house at "An der Elbe 33." Receives a visit in December at his Dresden studio from Grand Duke Nikolai Pavlovich of Russia (later Czar Nicholas I), who will acquire numerous paintings from Friedrich through the poet Vasily Andreyevich Zhukovsky. On this visit, the grand duke purchases *On the Sailboat* (p. 48) and *Sisters on the Harbor-View Terrace (Harbor by Night)* (p. 52).

1821	In June, visit from V. A. Zhukovsky. Friedrich's brother Heinrich visits during the summer.
1822	Visit from the poet Friedrich de la Motte-Fouqué. Paints *Moonrise by the Sea* (p. 56) and *The Lone Tree*.
1823	Dahl moves into the Friedrichs' house, "An der Elbe 33." The two artists exhibit together in 1824, 1826, 1829, and 1833, and receive joint commissions. Friedrich's daughter, Agnes Adelheid, is born on September 2.
1824	On January 17, he is appointed supernumerary professor at the Dresden Academy. Upon the death of Johann Christian Klengel on December 19, Friedrich is not given Klengel's professorship for landscape painting. In October he visits Georg Friedrich Kersting in Meissen. On December 23, his son Gustav Adolf is born. Friedrich is ill. Paints *The Sea of Ice (The Failed North Pole Expedition, The Wrecked "Hope")*.
1825	*The Watzmann* exhibited in the Dresden Academy. Paints *Graveyard Gate* (Fig. 24).
1826	Illness. During May and June, visits the island of Rügen to regain his health. At the very first exhibition organized by the Hamburger Kunstverein, Friedrich shows three works, among them *The Sea of Ice (The Failed North Pole Expedition, The Wrecked "Hope")*.
1828	In May visits Teplitz, in Bohemia.
1830	In March Friedrich is visited in his Dresden studio by Crown Prince Frederick William of Prussia.
1834	On November 7, the French sculptor David d'Angers calls on Friedrich. Paints *The Stages of Life*.
1835	On June 26, he suffers a stroke. The proceeds from the sale of several paintings to Czar Nicholas I enable him to spend the latter half of August and September in Teplitz for treatment. Because of his health, Friedrich now uses sepia and watercolor almost exclusively.
1836	Wilhelm von Kügelgen visits on March 2. Friedrich is very ill.
1838	On June 23, his brother Adolf dies.
1840	Friedrich dies in Dresden on May 7 and is buried there on May 10.